SHAKER
A Collector's
Source Book II

Don and Carol Raycraft

Cover photograph by Jean Ann Honegger
taken at Shakertown, Pleasant Hill, Kentucky.

Cover design: Geri Wolfe
Interior layout: Anthony Jacobson

21170

Library of Congress Catalog
Card Number 80-50497

ISBN 0-87069-443-X

10 9 8 7 6 5 4 3 2 1

Published by

Wallace-Homestead Book Company
580 Waters Edge
Lombard, Illinois 60148

One of the
ABC PUBLISHING
Companies

Contents

About the Authors

Don and Carol Raycraft, authors of twenty-five books on country antiques, live with their three sons on a four generation farm near Normal, Illinois. They live in a mid-nineteenth century barn which is charmingly decorated and furnished in Shaker and American country antiques. Both attended Illinois State University where she received a bachelor's degree in elementary education and her husband earned a bachelor's, master's and doctoral degree in education and psychology.

Acknowledgments

The authors are indebted to the following for their assistance in this project:

Collections
Doug and Connie Hamel
Miriam and Stephen Miller
Bob and Judy Farling
Dave and Barb Bertshe
David Newell
Patricia Adams
Dr. Stu Salowitz
Alex Hood
Jared Newell
Virginia Newell
Tracy Tucker
June and F.E. Hamel

Photography
Jon Balke
Bob Farling
Dr. Stephen Miller
Bill Hansen
David Newell
Doug Hamel
Carol Raycraft
R. Craig Raycraft

Illustration
Susan Freiburg

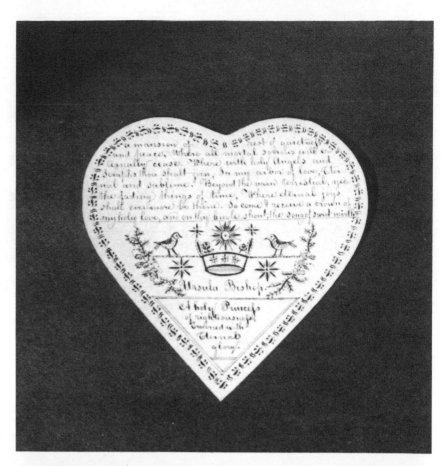

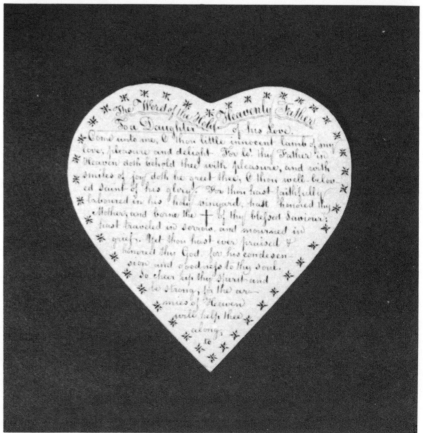

Shaker inspirational message from New Lebanon,
New York, 1844.

Introduction

While the number of collectors of American country antiques can be numbered in the thousands, there are considerably fewer individuals who actively seek Shaker-made antiques. The Shaker marketplace is especially interesting because there are countless surprises, huge egos, significant scholarship, few dealers, roller coaster prices, and minimal secrets.

Willis Henry has conducted a series of successful Shaker auctions in recent years. On June 30, 1984, he was quoted by the *Maine Antiques Digest* when he remarked, "Shaker buyers are picky buyers. I knew that from the other auctions, but they are really proving it today." Mr. Henry was referring to several prices that were either falling considerably above the pre-auction estimates or drastically below. A Hancock, Massachusetts, sewing cabinet that was pictured on the cover of the catalog had been estimated to be worth $25,000 to $30,000. It brought $9,900. Several dealers and collectors at the auction had some reservations about the top of the cabinet. These concerns limited the amount that the bidders were willing to risk. A wooden shovel carved from a single piece of wood was estimated at $300 to $400. The shovel brought $935.

Whether or not the top was "right" is of no concern. The point is that the primary Shaker dealers and collectors in the country were either present, represented by agents, or keenly aware of the Duxbury auction. If a hint of doubt was raised at the auction, the price was almost automatically diminished.

For a piece of Shaker furniture to bring a premium price it usually must have a documented provenance. A provenance provides the history of ownership and a reasonable guarantee that the piece is what it is alleged to be.

The Shaker market is so networked that a cupboard or table with a negative reputation, deserved or not, can become the ultimate white elephant.

There was a limited amount of Shaker furniture produced because few pieces, other than chairs, were sold to the "world" directly by the Shakers. As a direct result of the original limited supply, prices are high and dealers and collectors who enter the market are generally much more informed than collectors of country antiques. A mistake on a $1,500 dry sink at a show in Ohio is a lesser emotional or financial trauma than a miscalculation on a $15,000 blanket chest at a Shaker auction in Massachusetts.

The $1,500 blunder will not become the major topic of conversation among all other collectors of country antiques in the United States.

Values for American country furniture tend to be fairly stable from show to show or auction to auction. A blue step-back cupboard that is sold for $15,000 at an antiques show in New York City does not immediately send escalating price ripples throughout the nation and automatically raise the price of every cupboard in blue paint. In this diverse market it takes more than a single sale or auction to create instant and dramatic change.

A portion of the country antiques market is very susceptible to trends or fads. An article in *Country Living* showing a collection of doll quilts, windmill weights, or birdhouses can create an instant market for similar examples and send prices soaring until something else is highly publicized and takes its place. We were in Maine several summers ago at a roadside flea market and a dealer mentioned that she had been besieged with customers for birdhouses after the publication of a photographic essay in *Country Living*. She could not cut birdhouses out of trees in southern Maine fast enough to meet the demand. Her goal was to sell as many as possible before the "collectors" grew tired and their attention wandered to something else. Needless to say, a situation such as this could not occur in the Shaker collecting field.

1

A Conversation with Doug Hamel

Chichester, New Hampshire, Shaker dealer Doug Hamel became an antiques dealer almost twenty years ago when he cleaned out his father's garage and opened a shop. Since that day he has owned many of the finest products of Shaker cabinetmakers and has become an internationally recognized authority.

Doug and his wife Connie are both natives of Concord, New Hampshire, and are the parents of two daughters, Melinda and Lisa.

(D.R.) *Where does a potential Shaker collector go for direction?*

(Hamel) It is important that a beginning collector read as much as possible. There are a wealth of Shaker books that have been written over the past forty years. *Antiques Magazine* has been periodically publishing Shaker articles since the late 1920s. Today the *Maine Antiques Digest* and the *Ohio Antiques Review* keep Shaker collectors informed of pieces that turn up at shows and in auctions.

It is equally essential that collectors visit restorations and museums to see the best possible Shaker pieces. New things are learned no matter how many visits are made.

Many collectors tell me that finding a dealer whose judgment they can trust over a long period of time is important. The dealer works with the collector to build a representative and quality collection.

(D.R.) *Do you recommend that Shaker collectors buy at auctions?*

(Hamel) Auctions are excellent sources for purchasing antiques. You have to be very wary, however, of buying somebody else's "problems." By that I mean auctions are sometimes used by dealers to dump things they can't sell in their shops or by collectors who bought things they no longer want.

Collectors should preview the auction and examine anything they might want to buy very closely. If you have any questions about a piece, hire an expert to look at it and give you an experienced opinion. You should also have some predetermined price limit for the piece. Never allow emotion rather than intellect to control your bidding.

If you are a novice, it's not a bad idea to hire an experienced dealer to represent you at the auction and bid for you. Normally, the charge is 10 to 15 percent of the selling price of the piece. On a very expensive piece this fee can sometimes be negotiated between the dealer and the buyer.

(D.R) *How has the Shaker market changed in recent years?*

(Hamel) As prices have increased significantly, the biggest change I have observed is the number of people who show up at the auctions.

If a spectacular Shaker desk or community chair becomes available and it could rank as a "10," there are a lot of people who want it and the price is usually very high. A portion of the market looks only for the "best," and they have the means to pay consistently for it. What is surprising to me is that I see a lot of "6" and "7" level Shaker furniture with little demand and oftentimes, low prices. To me these are the best buys and may be overlooked.

Shaker collectors who pay five figure prices do not like "rough" stuff. Condition is critical to them and problems with the surface of a piece can really hurt it in their eyes.

(D.R.) *How important is provenance?*

(Hamel) Provenance is critical if the piece has a "non-classic" form. This is a piece that differs from the form commonly seen in auctions or in collections. A provenance or history of the piece is very important to document that the "non-classic" piece is Shaker.

If a #7 production rocking chair turns up, nobody cares who owned it because there were thousands of them made.

(D.R.) *Why do some oval boxes sell for $500 and a seemingly similar box sell for $5,000?*

(Hamel) The oval box market is determined by supply and demand. Price may be of no concern if a collector, who has spent several years building a stack of nine or ten boxes, suddenly finds a box that is precisely the color and size he needs to complete his stack.

He knows that he may never have another opportunity to complete his stack so he just keeps bidding until the auctioneer says "Sold."

(D.R.) *If a collector can't afford a five figure sewing desk or candlestand, what should he or she collect in today's escalating market?*

(Hamel) Regardless of the amount of money somebody has to spend, they should be selective in what they buy. If they want a production rocking chair, they should not necessarily buy the first one they see because there are many from which to choose. Don't buy "mistakes." Take the time to find something that is in good condition and fairly priced.

I think collectors today might look for Shaker tinware, woven poplar "fancy" goods, pails, and paper labels. If you know what to look for, you can occasionally find seed catalogs, Shaker publications, and other paper materials.

The most important point to remember is not to buy something merely because it says "Shaker" on the price tag. Do some research or find someone whose knowledge you trust to assist you.

2

Historical Perspective

There has been a wealth of books written over the past fifty years detailing the historical development of the Shaker movement in the United States.

This overview is intended to provide the reader with some insights into the Shaker philosophy, lifestyle, and business techniques.

The founder of the Shaker movement in America was Ann Lee(s), the daughter of a Manchester, England, blacksmith who resided on Toad Lane. She was born in 1736 and baptized on June 1, 1742. Her formal education was limited and she went to work in a textile mill in Manchester at a youthful age.

In 1758 she became a member of a religious group that followed many of the tenets of the Quaker faith. The "believers" became so animated and engulfed with the spirit during their religious services that onlookers described them as "Shaking Quakers."

On January 5, 1762, Ann Lee married Abraham Standerin. Lee and her husband had four children, all of whom died at a very young age. The deaths of the children had a profound effect on Lee and shaped the remainder of her life.

In 1772 she and her father were arrested for disrupting Anglican church services. For the next two years there were constant confrontations with public officials, angry mobs, and the Anglican church.

On August 6, 1774, Lee arrived in New York on the ship *Mariah* after a three-month crossing. She was accompanied by seven followers and her somewhat reluctant husband, Abraham Standerin. Standerin had serious problems giving up the desire for "cohabitation" that his wife had proclaimed "the source of all evil." His marriage to Ann Lee ended at some point in 1775.

The wandering group finally settled eight miles west of Albany, New York, in a place called Niskeyuna, leased some property, and built a log cabin.

The Shaker movement was greatly assisted by a general religious revival in New England that began in the 1730s. There were a large number of people looking for answers to a philosophical dilemma and "Mother Ann" or "Ann the Word" and her followers provided a new direction of spirit and faith. The Shakers offered a life-style that differed significantly from that of the "world." The "superfluities" of life meant little to the Shakers and this had great appeal to many converts.

The guiding principles of the new communities and members were confession of sin, chain of authority, common ownership of goods, isolation from the "world," equality of the sexes, and celibacy.

The problems that befuddled the Shakers in England resurfaced in America in 1780. Many colonial Americans viewed the English Shakers with suspicion because of their refusal to bear arms during the Revolutionary War. Several of the members were jailed for refusing to serve in the colonial army.

Between 1780 and 1783 there were numerous confrontations between the Shakers and the "world." Wild rumors about their life-styles, patriotism, and the strange practice of celibacy created almost daily strife.

On September 8, 1784, Mother Ann Lee died at Niskeyuna, New York. The years of poverty, the deaths of her children, a long crossing from England to America, time on the road promoting her faith, and the physical stress caused by the mobs had combined to bring about her premature demise.

By 1830, the Niskeyuna (Watervliet) community that Lee founded had been joined by eighteen others with locations ranging from Maine to Indiana and Kentucky. By the 1840s there were more than six thousand members.

One of the early devices used by the Shakers to maintain their membership was the recruiting of children and adolescents.

The Shakers allowed children to join their communities when they entered with their families or by signing an "indenture" with a child's parents. The "indenture" was a legal agreement between the Shaker community and the parents guaranteeing that the child would be fed, housed, taught a trade, and educated. The parents waived all legal right to the child. At the age of twenty-one, the boy or girl was free to make a decision about staying with the Shakers or returning to the "world."

After the mid-1860s, it became extremely difficult for the Shakers to keep young members when the time of choice arrived. The increasing number of jobs available in factories in nearby cities drew many of the youthful Shakers who probably would have remained a generation earlier.

Eventually, several Shaker communities refused to take children unless an entire family joined. The "drop-out" rate was so high that the Shakers' investment in educating and lodging the children could never be returned. The Shakers did accept young people in their twenties who had had a "taste" of the "world's" pleasures and decided to give them up.

The young boys and girls who did join a community lived in the Children's Order and were supervised by "caretakers." The boys and girls lived apart and remained in the Order until the boys were sixteen and the girls reached fourteen.

The Shaker schools placed major emphasis on handwriting, arithmetic, spelling, reading, and the teaching of good manners.

In the 1850s some of the Shaker schools added geography, grammar, and music to their curriculums. Learning a variety of "practical" or vocational skills was also highly regarded.

The schools and the Children's Order were not advocates of corporal punishment. On rare occasions an older child might be spanked or switched for a misdeed, but younger children were rarely spanked. The Shakers tried to discipline the children by instilling within them a love for their community and a fear of the "world."

The following statement was found in a document intended for the young scholars of the Children's Order:

> *If you are not obedient, you shall go to the world, where you can have your way, and do as you have a mind to, live in sin, and dress in the gaities of Babylon, to the ruination of the soul.*

The Shaker children had numerous opportunities for play. They had regular gymnastic sessions, fishing excursions, sleigh rides, picnics, and marble games.

Shaker Chronology

1736 Ann Lee(s) born in Manchester, England

1758 Lee (age 22) joins a religious group in Liverpool

1762 Lee married Abraham Standerin

1774 Lee and a few followers leave England and travel to New York

1780s Shakers begin marketing oval boxes

1784 Lee dies in Niskeyuna (Watervliet), New York

1787 A Shaker membership of 1000

1790s Shaker seed industry begins

1805 Three Shaker brothers travel West to develop communities in Indiana, Kentucky, and Ohio

1840s Membership grows to more than 6,000 in nineteen communities from Maine to Kentucky

1850s Rocking chairs made at New Lebanon, New York, are sold to the "world" in large quantities

1861 New Lebanon becomes Mount Lebanon with a change in the post office

1871 Shaker magazine begins publication in Canterbury, New Hampshire. The magazine continues under several different names for twenty-nine years until 1900

1876 Shaker booth at Philadelphia Exposition wins awards and increases chair sales

1880- "Fancy goods" stores operate in several New England com-
1920 munities selling to visitors and tourists

1900 Shaker seed industry permanently closes due to competition and declining membership

1902 Several Shaker communities indicated that they would accept no new members who were in poor physical condition or more than fifty years of age

1947 Mount Lebanon closes and the remaining members move to Hancock, Massachusetts

1961 Brother Delmar Wilson, the last male Shaker, dies at Sabbathday Lake, Maine

1986 Communities at Canterbury, New Hampshire, and Sabbathday Lake are still in operation

3

Shaker Furniture

A student of Shaker furniture needs three books for a basic reference library. These include: John Kassey, *The Book of Shaker Furniture* (University of Massachusetts Press, 1980); Robert Meader, *Illustrated Guide to Shaker Furniture* (Dover Press, 1972); Charles Muller and Timothy Rieman, *The Shaker Chair* (The Canal Press, 1984).

The gentlemen whose books are mentioned above have taken the study of Shaker furniture to heights never approached by researchers in the field of American country furniture.

The Shakers took exacting care with the quality of their furniture. They categorized their output into shop furniture and dwelling furniture. Tables, benches, and chairs used in the various work areas were as skillfully crafted as the beds in which the Shakers slept.

Shop furniture was generally made from the white pine found in huge quantities on the Shakers' property in each of their New England communities. White pine was a relatively simple wood to work with and could be finished with varnish, paint, stain, shellac, or a "wash." A "wash" was created by thinning paint with water and allowing the natural grain of the wood to show through the paint. The Shakers used pine in "dwelling" furniture when they constructed six-board chests, headboards for beds, benches, woodboxes, tables, and "built-ins." In the "world" an architectural cupboard was built into a wall as a permanent part of the house. The Shakers' white pine "built-ins" were a product of their desire for perpetual neatness and order. Walls of drawers were commonly found in sleeping rooms and attics in the New England communities.

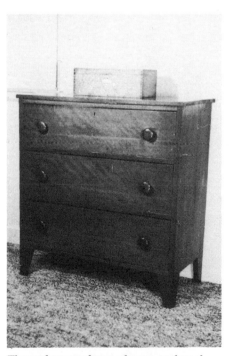

Three-drawer chest, cherry and curly cherry with original orange red varnish finish. (Miller Collection)

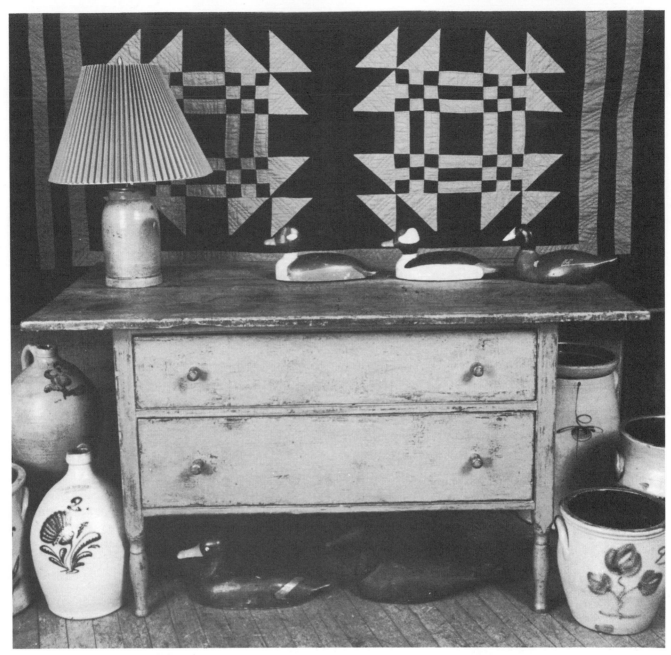

Low work table, cherry and pine,
moss green paint, Canterbury, New
Hampshire, c. 1810–1820. (Patricia
Adams Collection)

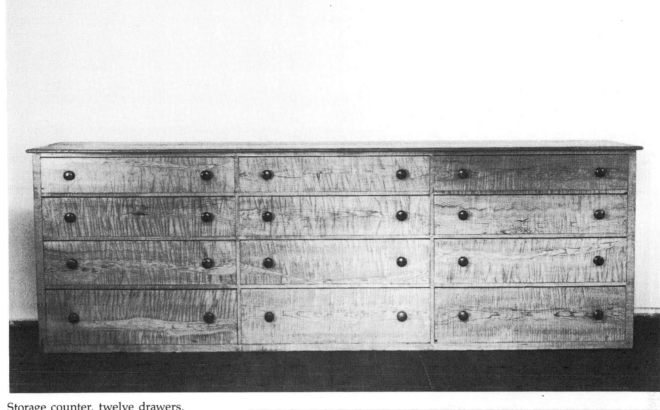

Storage counter, twelve drawers, Alfred, Maine, pine with grain painting, 1830–1840s.

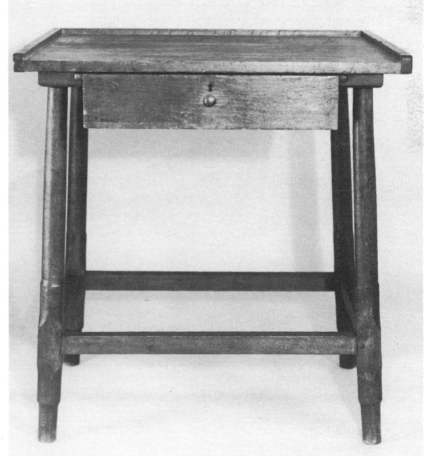

Work table, yellow birch and pine, Enfield, New Hampshire, stretcher base with "double step" turnings on legs, c. 1820s.

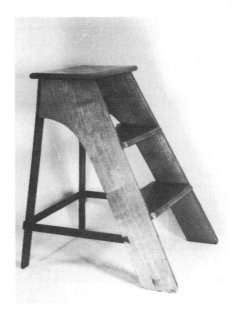

Step stool, butternut with cherry rear legs and stretchers, finished with clear varnish, 23" high. (Miller Collection)

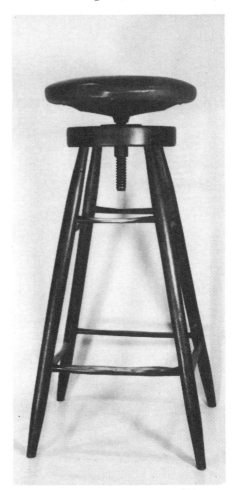

Tall stool commonly found in Shaker workrooms. (Miller Collection)

Much of the hardware (latches, hinges) used on Shaker-made furniture and "built-ins" was purchased from manufacturers in the "world."

The Shakers did not make much furniture, other than footstools and chairs, for sale to the "world's" people. The only way that isolated pieces filtered out of a Shaker community was through a dispersal auction after a community closed, when the Shakers sold an extra item to a tourist visiting one of the sisters' shops, or, on rare occasions, when a gift was given to someone who had helped or provided the Shakers with a service.

As communities began to close after the Civil War, the surviving membership had no use for many of the shop and dwelling pieces of furniture, and auctions were conducted.

Some insights into the Shakers' attitude about their furnishings can best be appreciated by considering four statements from the Millennial Laws that were updated and finally issued in 1845.

1 Whatever is fashioned, let it be plain and simple, and of the good and substantial quality which become your calling and profession, unembellished by any superfluities, which add nothing to its goodness or durability.

2 All beauty that has not a foundation in use, soon grows distasteful, and needs continued replacement with something new.

3 Beauty rests on utility.

4 We find out by trial what is best, and when we have found a good thing, we stick to it.

The Shakers emphasized quality, durability, and function in the furniture they constructed. Their designs changed very little before the Civil War. In the 1870s a declining membership forced the Shakers into making some compromises with the "world" from which they had withdrawn almost a century before.

The growth of major corporations after the war brought competition to the Shakers for the first time. When a Shaker "industry" reached the point where it was no longer profitable, the Shakers turned to something else. In 1869 a woolen mill at Union Village, Ohio, was closed, and by 1900 the Shaker seed business, which had been extremely profitable for a century, could not meet the competition from several national nurseries.

When a piece of furniture was needed, it was simpler to purchase it from a local store than to make it within the community.

The increasing contacts with the "world" and the periodic adoption of bits and pieces of its culture brought significant change to the Shaker life-style by the turn of the century.

In 1890 the Mount Lebanon community installed a telephone system, and by 1910 Brother Delmar Wilson was driving a car at Sabbathday Lake, Maine. Checkers, picnics, jigsaw puzzles, and folk dancing were popular forms of recreation.

Between 1880 and 1920 eleven Shaker communities closed due to a steadily declining membership.

Notes on Collecting Shaker Furniture

"Western" Furniture. The Western Shaker communities in Kentucky and Ohio began in 1803 when three Shaker brothers traveled West to spread the word of Mother Ann. The last western community closed in 1922 at South Union, Kentucky.

It is difficult for most collectors to distinguish Shaker furniture made in Ohio and Kentucky from local pieces made during the same period by craftsmen in the "world."

After 1850 not a great deal of furniture was made by Shakers in Ohio and Kentucky.

Western Shaker furniture typically contains more elaborately turned legs and applied moldings than the work of the Eastern Shakers.

The Western furniture craftsmen made more use of cherry, butternut, poplar, and walnut than their New York and New England brothers who favored pine.

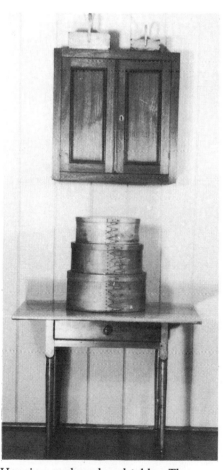

Hanging cupboard and table. The one-drawer table of curly birch and cherry is considered to be classic Canterbury, New Hampshire, form. The hanging cupboard is constructed entirely of walnut and is from Enfield, Connecticut. (Miller Collection)

The interior of the hanging cupboard provides a display of a variety of cardboard containers from several New England communities. (Miller Collection)

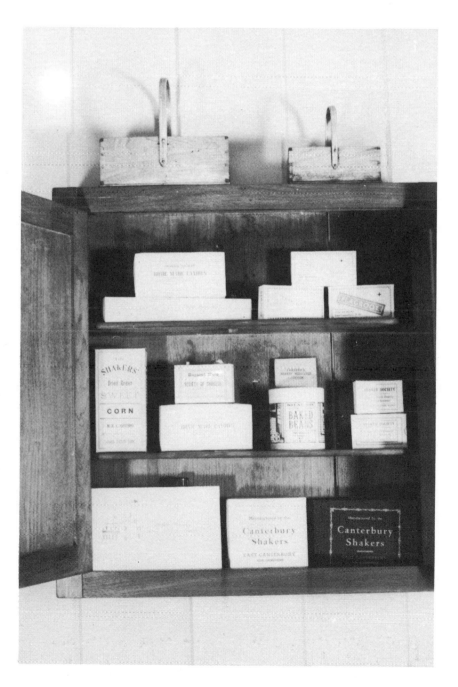

19

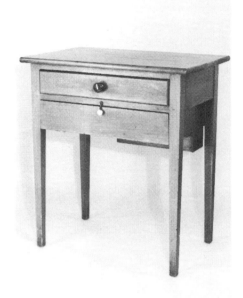

Document table, cherry and butternut, mid-nineteenth century, Bennington-type Rockingham drawer pull, pencil drawer opens from side, Enfield, Connecticut.

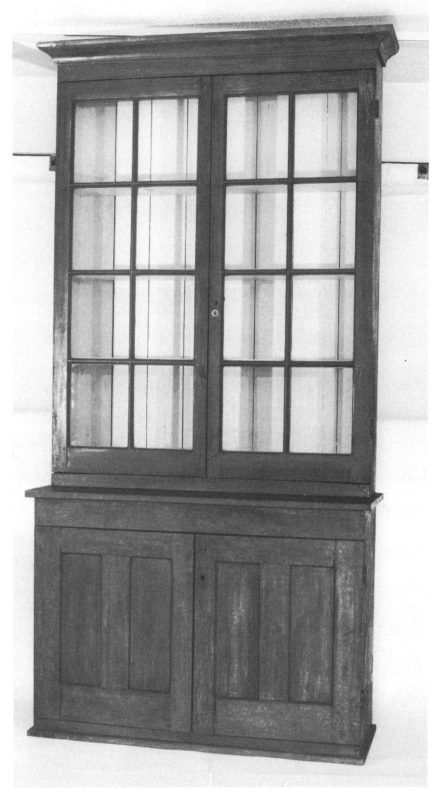

Hymnal cupboard, Pleasant Hill, Kentucky, poplar and cherry woods, "cantaloupe orange" paint, two pieces, c. 1840.

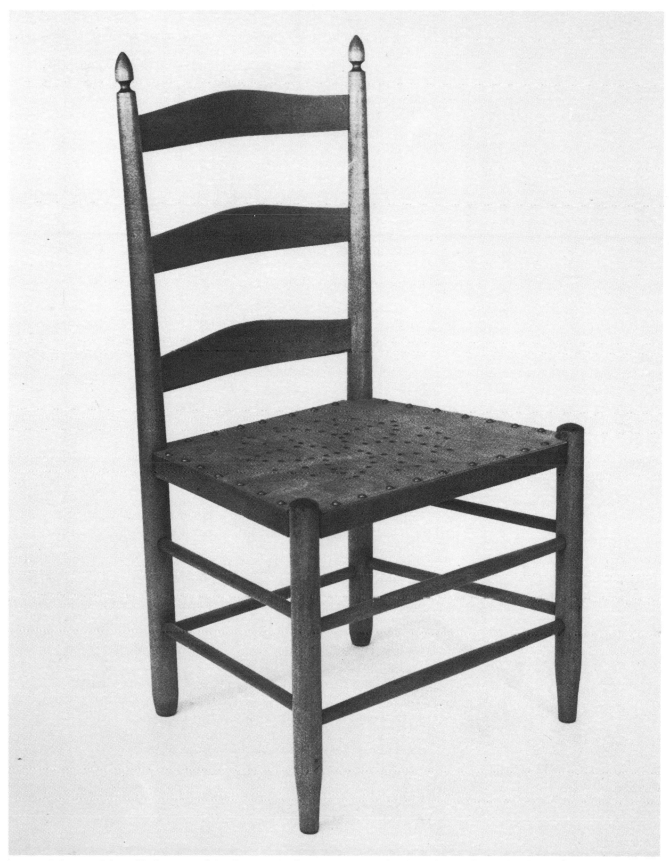

Mount Lebanon "chapel" chair, used in the meetinghouse, impressed "3" on back of top slat, late 1880s. The punched plywood seats were purchased from the "world" for use on the chapel chairs. Even though the chairs were numbered, they were used only within the Mount Lebanon community.

"Eastern" Furniture. It is difficult to date Eastern Shaker furniture because styles did not change significantly between the 1820s and the 1870s.

Unless a piece has a detailed provenance or specific style characteristics (leg turnings or chair finials), it is almost impossible to determine from which community it originated.

Maple was often used for table legs, bedposts, chair posts, oval boxes, mirror frames, tools, and candlestands.

Pine was generally chosen for drawers, cupboards, chests, tailoring counters, benches, and washstands.

Utilizing thinned paint or "wash" was much more common to New England furniture than Western Shaker furniture where the technique was rarely executed.

Auction and Antiques Show Prices of Shaker Furniture

Hancock Shaker Village Show, October 1-2, 1983

Mount Lebanon #7 rocker with finials and taped back and seat	$1,100
Weaver's stool from Maine with yellow "wash"	1,675
Sabbathday Lake pie safe, red paint and screen front	2,950
Sideboard server from Kentucky with tiger maple panels	4,500
"Two-step" stool with label	525
Mount Lebanon #7 rocking chair with cushion rail	1,100
#3 rocking chair	325
#4 straight chair	750
Child's blanket chest from Sabbathday Lake	950
#3 Mount Lebanon straight chair	350
#6 rocking chair with cushion rail	875
Bentwood rocking chair	375
#1 child's rocking chair	1,250
#5 rocking chair with finials and a taped back and seat	850
New Lebanon blanket chest in butternut wood and original paint	4,500

Duxbury, Massachusetts, auction, June 30, 1984

Blue gray blind front cupboard with paneled door, 6'3½" high	$4,950
Canterbury, New Hampshire, side chair, original finish and tilters	2,200
Sabbathday Lake blanket chest, original green paint, lift top with three drawers below	15,400
Mount Lebanon, New York, revolving chair in black paint, c. 1830	6,600
Chrome yellow three-slat Watervliet rocking chair	1,540

Sabbathday Lake, Maine, auction, June 20, 1972

Two-door cupboard with clothespin pulls, 75" high x 29" wide x 14" deep	$700
Henry Greene sewing desk with twelve drawers, Alfred, Maine, butternut and maple, 40½" tall x 31" wide x 24" deep	3,250
Sabbathday Lake one-door cupboard, used in dairy room, 53" high x 26" wide x 8½" deep	275

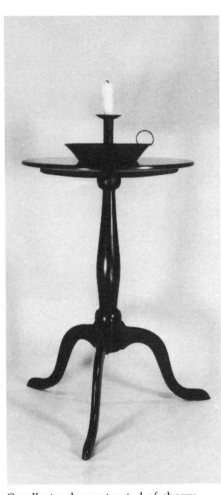

Candlestand, constructed of cherry with a chamfered butternut top, covered in a clear varnish. (Miller Collection)

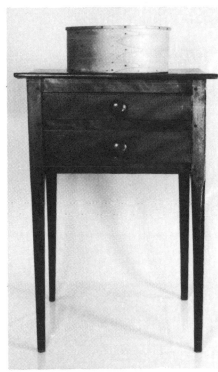

Two-drawer stand and spitbox. The stand is made of curly birch and is probably from one of the Maine communities. The three stiles are tenoned into the leg posts and pinned. The fingered spitbox is painted chrome yellow. (Miller Collection)

Maine auction of Mount Lebanon, New York, Shaker antiques, June 19, 1973

Revolver or swivel chair, 26" high, chestnut, maple and pine	$1,000
Pine, two-door panel end cupboard with five drawers	1,700
#6 rocking chair with arms	125
Bed with wooden rollers and traces of old green paint	625
#7 signed rocking chair with cushion rail	255

New York City auction of the Lassiter collection, November 13, 1981

Benjamin Youngs tall case clock	$26,000
Curly maple side chair with tilters	4,180
Pine cupboard, blind front, from Mount Lebanon	12,500
Pine and maple worktable with two drawers from Mount Lebanon	5,000

Pittsfield, Massachusetts, auction, Summer, 1985

Production rocking chairs from Mount Lebanon, New York	
#0 without arms	$1,375
#1 without arms	990
#3 without arms	440-660
(several were sold)	
#7 without arms	1,045
#7 with arms	1,320
Fitted sewing box with swing handle	385
New Lebanon, New York, high chair	11,000
Set of four butternut carriers, rectangular in form with dovetailed sides	8,800
Salmon painted chest, bracket base, four drawers	3,300

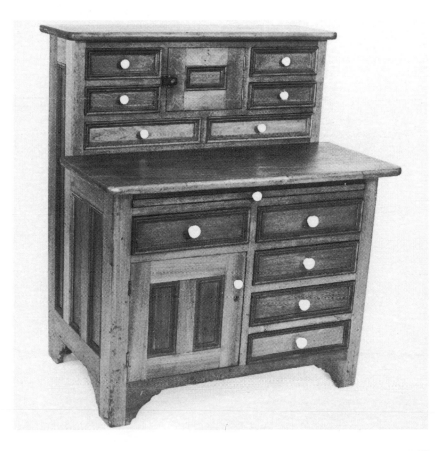

Sewing desk of mixed woods, late nineteenth century, Canterbury, New Hampshire, attributed to Elder William Briggs.

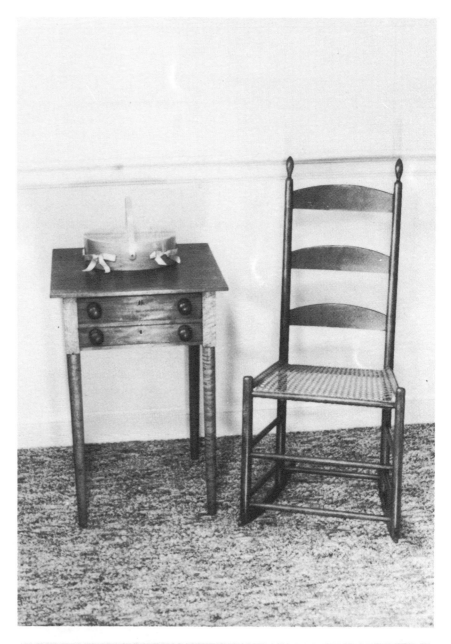

Two-drawer stand and rocking chair. The Maine sewing stand is made of mahogany and bird's-eye maple. The armless rocking chair is constructed of birch and is from Enfield, New Hampshire. (Miller Collection)

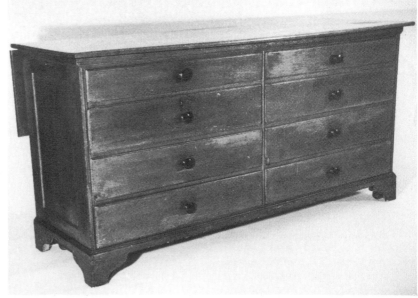

Eight drawer tailoring counter, Canterbury, New Hampshire, c. 1830, pine case with "figured" birch top, dovetailed bracket base.

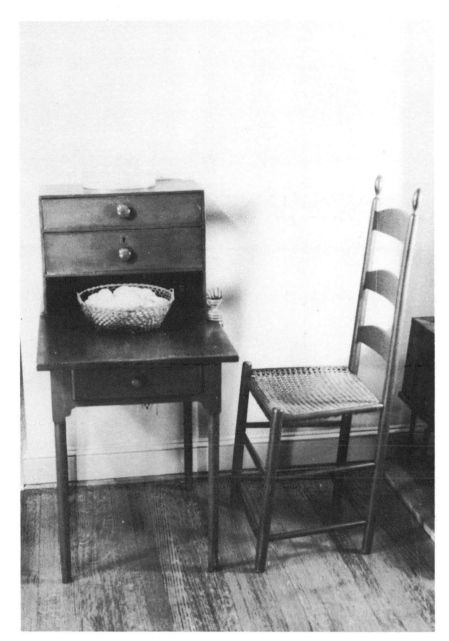

Enfield, New Hampshire, sewing table and chair. The sewing table and chair have original red paint. The table is constructed of birch and has a pine two-drawer top that was added by the Shakers at some point after the base was made. The tilter chair has its original cane seat and the room number "12" is stenciled on the back of the top slat. (Miller Collection)

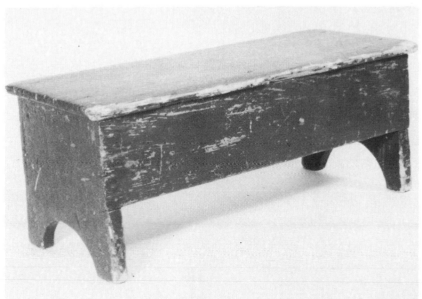

Painted pine footstool, green, "half-moon" cutouts on each side, mid-nineteenth century.

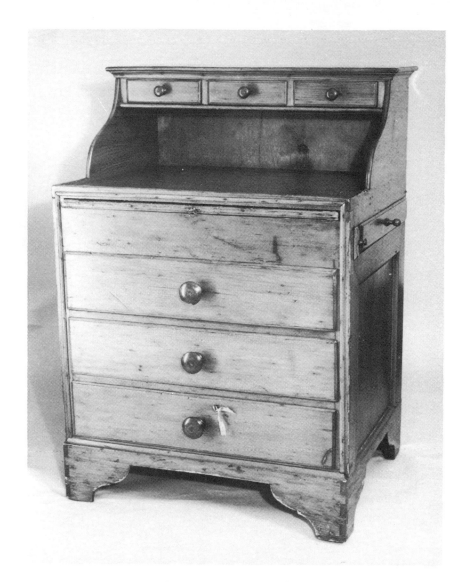

Sewing desk, dovetailed bracket base, pattern drawer at side, Canterbury, New Hampshire, cherry "Canterbury-type" knobs, c. 1830.

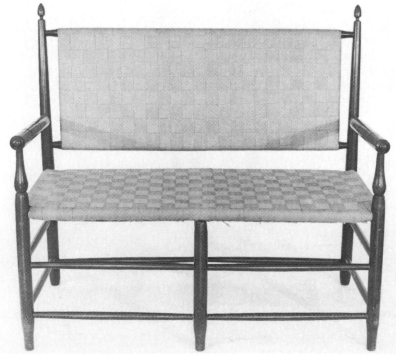

Six-legged settee, original bright yellow taped seat and back, Mount Lebanon, New York. This unusual six-legged settee is probably a unique example as no others are known to exist.

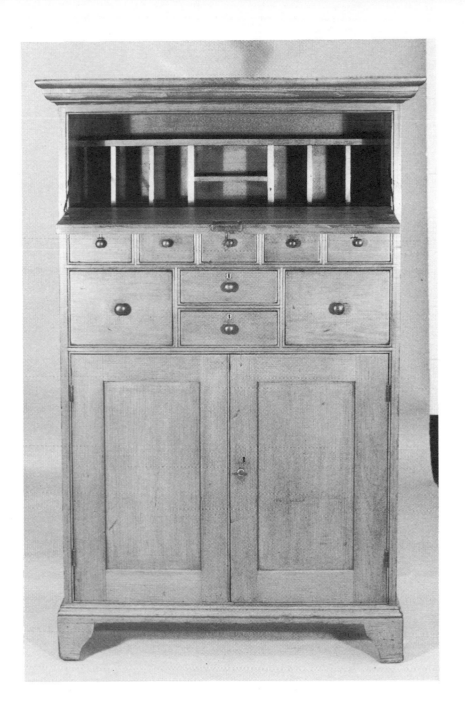

Enfield, New Hampshire, infirmary
desk, c. 1850, pine, uncommon form.

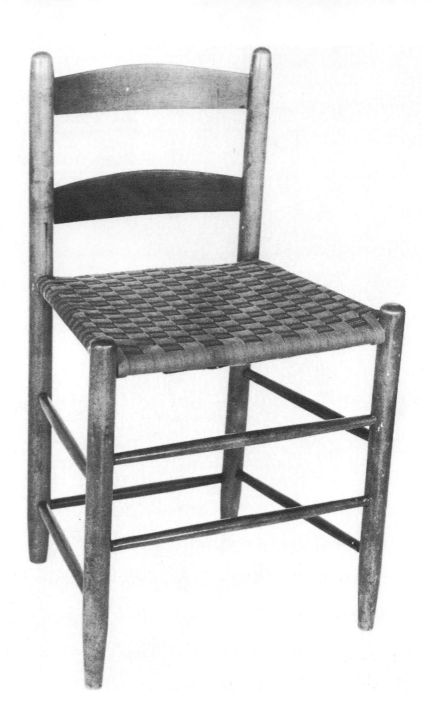

Mount Lebanon, New York, two-slat
dining chair, maple, c. 1830s.

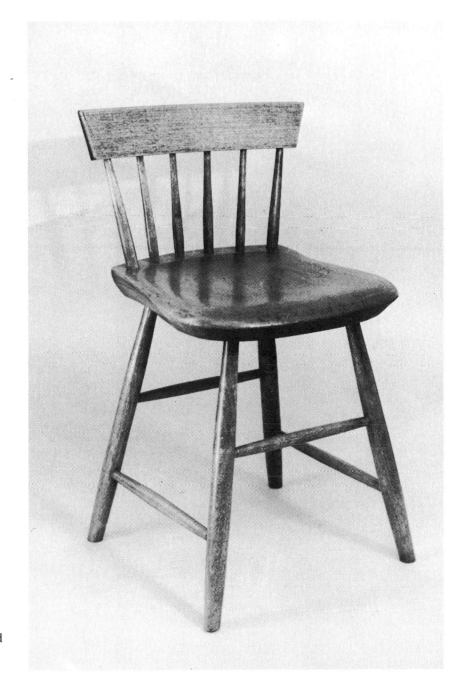

Enfield, New Hampshire, plank-seated dining chair, yellow birch with pine seat, c. 1830–1840.

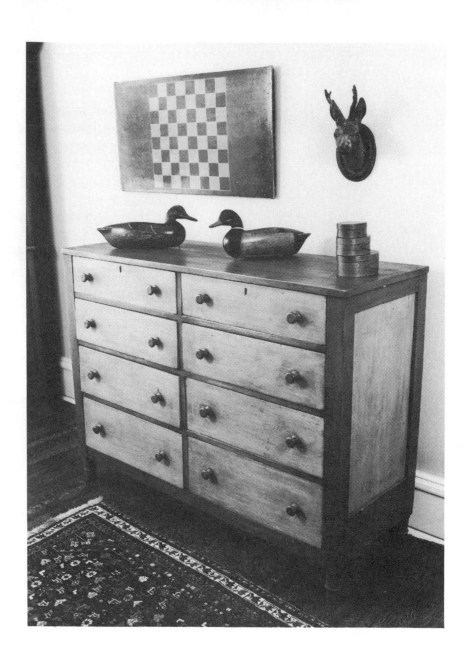

Chest of drawers, poplar, pine, and
ash, Watervliet, New York, c.
1830–1840. (Patricia Adams Collection)

Sabbathday Lake lap board, alternating strips of dark walnut and yellow pine held together by two cleats on the backside. (Miller Collection)

Measuring marks are hand-stamped into the fourth dark strip from the top. The board measures 36″ x 20″.

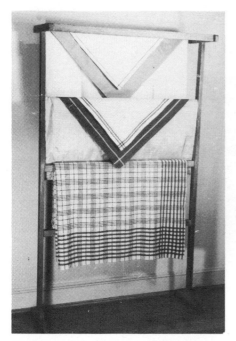

Drying stand, pine with shoe feet,
blue gray paint. (Miller Collection)

Among the scarves on the stand is one that belonged to Sister Maryann
Joslyn (1843–1924) of Enfield, New Hampshire. The "15" was her room
number and the "61" refers to the year in which she became eighteen
years old or reached her majority.

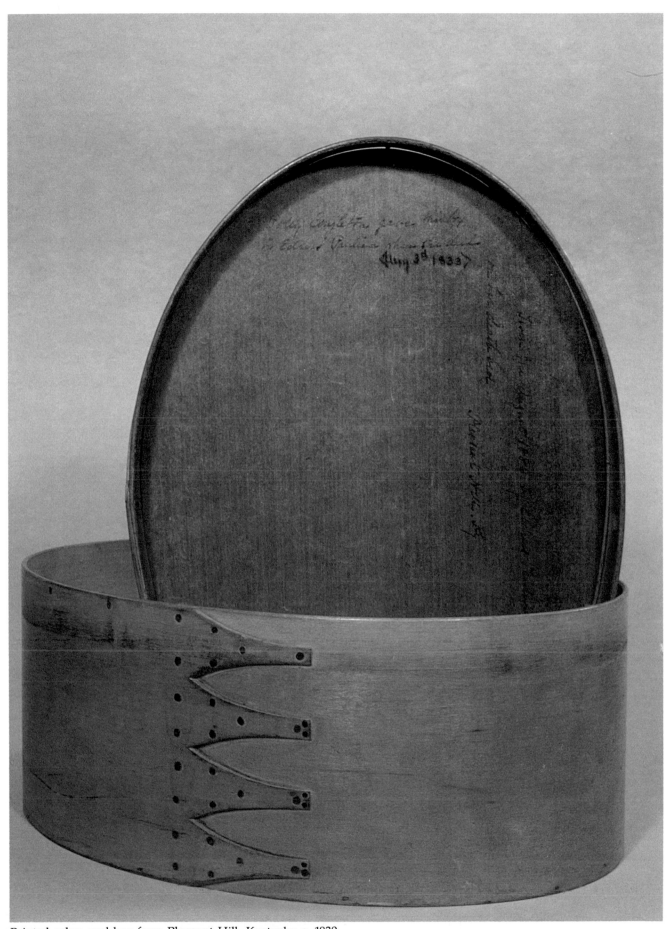

Painted ochre oval box from Pleasant Hill, Kentucky c. 1830.

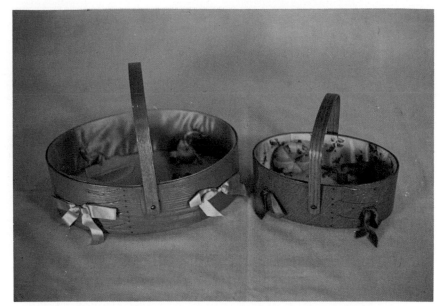

Lined sewing carriers sold in the sisters' shops. (Miller Collection)

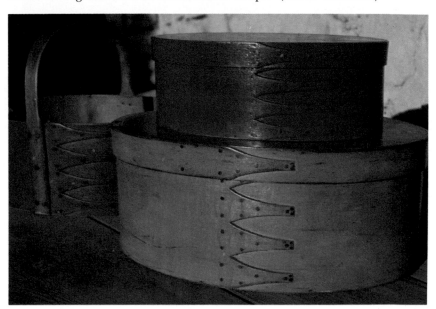

Fingered boxes.

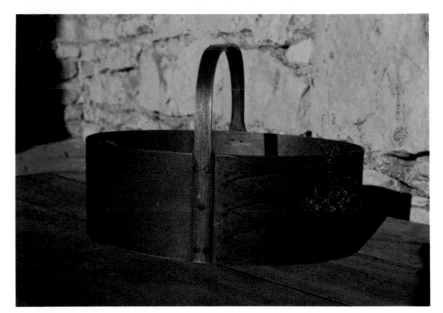

Fingered carrier.

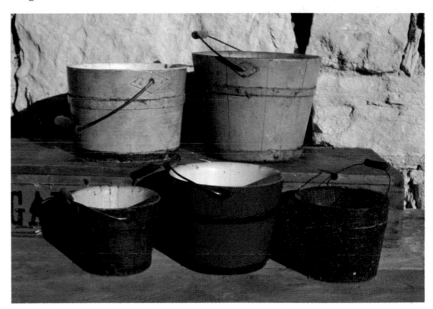

Painted pails with staved construction and iron bands.

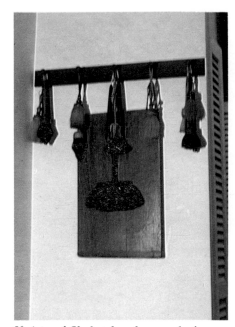

Variety of Shaker brushes made for sale to the "world."

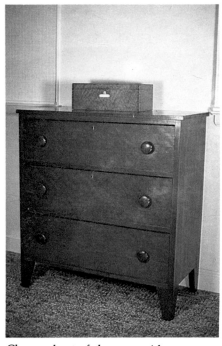

Cherry chest of drawers with orange-red varnish finish. (Miller Collection)

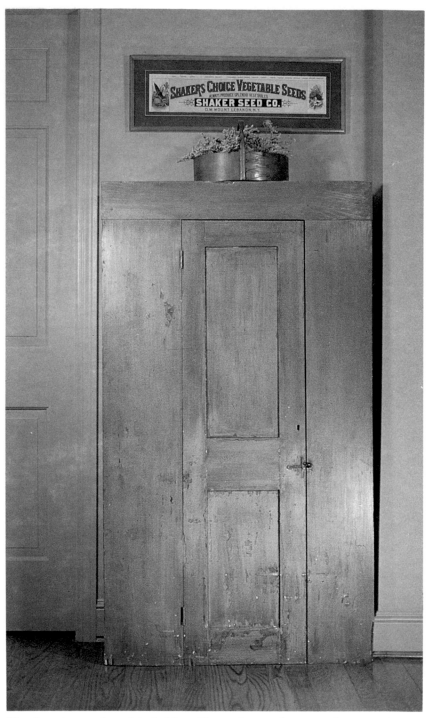

Pine hanging cupboard in brilliant blue paint used as a medicine cupboard at Sabbathday Lake in the infirmary of the Girls' Shop. (Miller Collection)

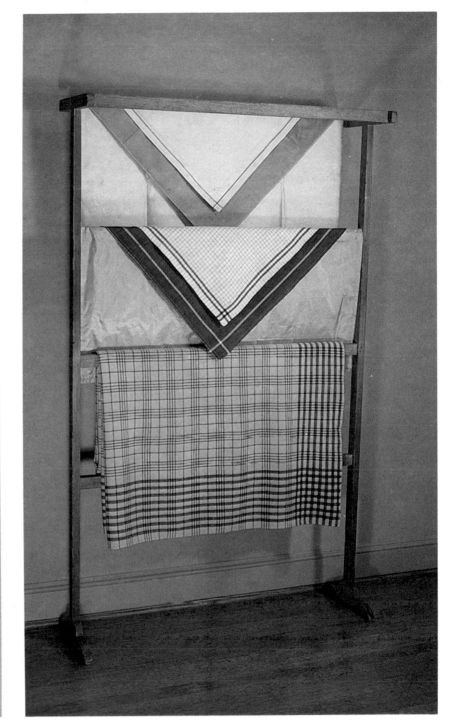

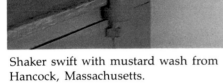

Shaker swift with mustard wash from Hancock, Massachusetts.

Pine drying stand with shoe feet and gray blue paint. (Miller Collection)

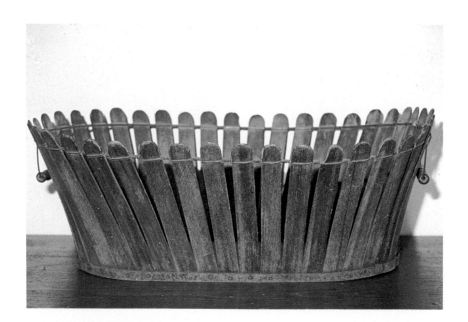

Wool gathering basket, New England, late nineteenth century.

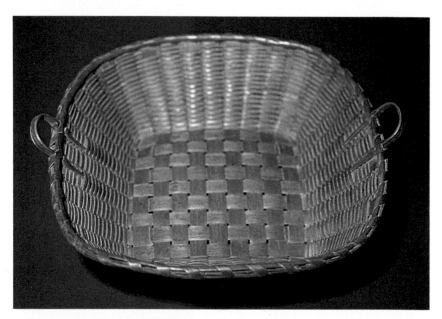

Shaker mending basket with "filled" interior and splayed sides.

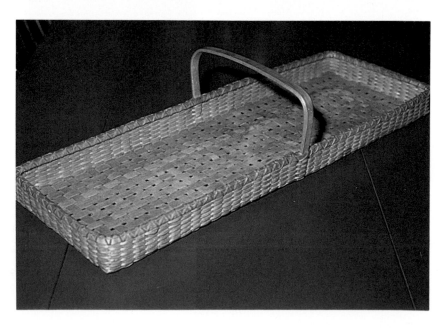

Shaker apple drying basket.

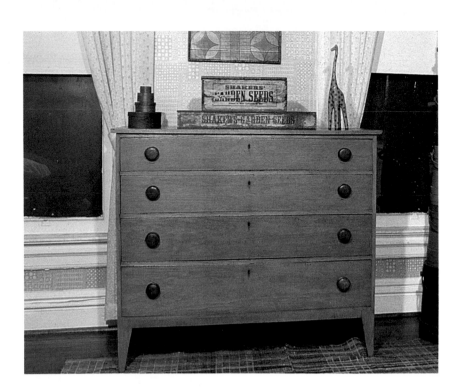

Enfield, Connecticut, four drawer chest in butternut with yellow wash.

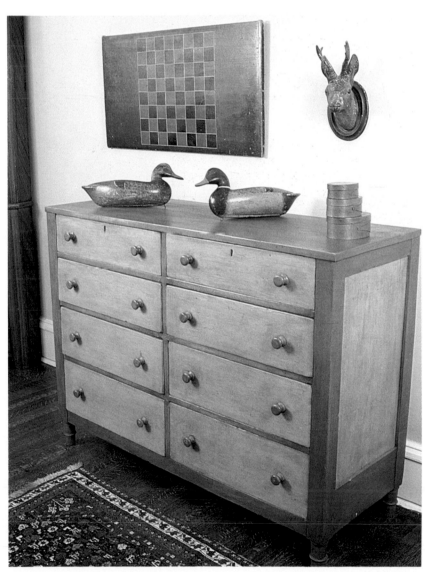

Chest of drawers, Watervliet, New York. (Adams Collection)

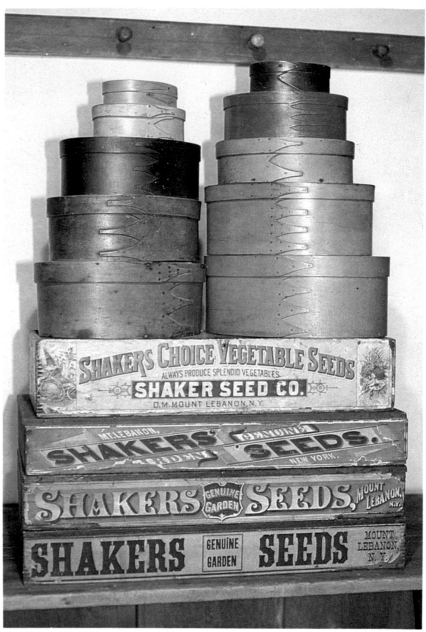

Oval boxes and Mount Lebanon seed boxes.

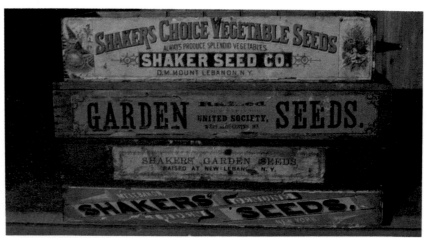

Shaker seed boxes from New Lebanon, Mount Lebanon, and Sabbathday Lake.

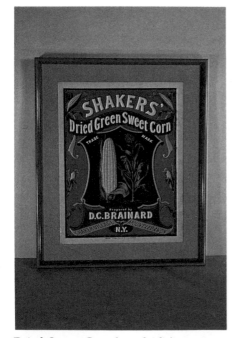

Dried Sweet Corn broadside/poster, late nineteenth century. (Miller Collection)

4

Rocking Chairs

The Mount (New) Lebanon Shakers were in the chair business from the 1780s until the early 1940s. In the 1790s two Shaker brothers traveled within a one hundred mile radius of their community in a horse-drawn wagon selling chairs.

They sold straight chairs and rocking chairs that were originally designed for the ill or elderly. The legs were socketed directly into the rockers on the early chairs. Also, the rockers on the chairs of the early 1800s did not extend beyond the front legs or posts.

In the 1830s "common" rocking chairs with no arms sold for $2.50. The early chairs had splint seats that eventually were replaced by checkerboard patterned worsted wool "taped" seats. The "tapes" were referred to as "braids" or "lists." The Shakers also used cane, leather, and rush for seating material.

The Mount Lebanon chair factory took on a new look in the mid-1860s when a decision was made to reorganize and revitalize the entire operation. Brother R.M. Wagan decided that a great deal of money could be made if the Shakers placed their primary emphasis on rocking chair production.

The parts of the chair could easily be standardized and were not difficult to assemble. Also, it did not require a skilled labor force to produce a finished product. After 1863 the vast majority of sales were rocking chairs. In the 1850s the Shakers had sold more straight chairs than any other form.

R.M. Wagan and Company issued a catalog in 1874 that solicited mail-order business. By this point at least forty-six variations of the rocking chair could be purchased. The chairs were made in eight sizes and a homemaker could select an example with or without arms and cushion rails.

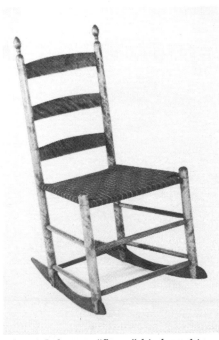

Mount Lebanon "flame" birch rocking chair, used within the community, c. 1840.

The largest chair was the #7 and the smallest was a #0 that was especially designed for infants.

In addition to winning an award for excellence at the Philadelphia Exposition in 1876, the Shakers sold the chairs to department stores in Boston, New York, and Chicago.

The chairs could be selected from several colors. These included ebony, "white," mahogany, walnut, and "cherry." The "white" was a chair left in the natural maple with no stain. The chairs were dipped into a vat of "color" or stain and hung up to dry.

The rockers and legs of the production chairs from Mount Lebanon were made of maple. The wood screws that held the rockers to the legs were commercially made outside the Shaker community.

Peg-tops on the front posts extend about a half inch through the arm of the chair. The mushroom cap was designed to cover the peg-top. The mushroom on the late production chairs was more dome-shaped than the earlier, flatter examples.

Finial of #7 production rocking chair that was in common use for more than sixty years at Mount Lebanon.

On December 28, 1923, a fire at Mount Lebanon destroyed the building that housed the chair factory. After the fire the Shakers were forced to purchase some stretchers, arms, and posts from the "world."

The death of Sister Lillian Barlow in February, 1942, and the problems of securing workers and materials due to World War II put a final end to the declining chair industry at Mount Lebanon.

The community closed permanently in 1947, and the surviving Shakers moved to Hancock, Massachusetts.

Rocking Chair Chronology

1789 New Lebanon, New York, Shakers make and sell chairs
1790s Slossan brothers sell Shaker chairs from a horse-drawn wagon
1830 The armless "common" chair was priced at $2.50
1830s Worsted wool tapes or "lists" first used for seats
1845 Shaker membership reaches peak of more than 6,000
1850s Cushion rail added to some rocking chairs
1852 "Tilter" chair patented by Brother George Donnell
1860s (Early.) Size of rocking chairs numbered for the first time
1863 Robert Wagan begins to reorganize the chair industry
1870s Shakers hire outside workers from the "world" to varnish chairs
1874 Chair catalog issued for mail-order business
1876 Shakers receive an award at Philadelphia Exposition
1883 Robert Wagan dies (November 29)
1900 Shaker membership drops to less than 1,000
1923 Five-story chair factory at Mount Lebanon destroyed by fire (December 28)
1935 Twilight of the Shaker chair industry at Mount Lebanon
1942 Production of chairs ceases at Mount Lebanon
1947 Mount Lebanon community closes

Impressed "7" from production rocking chair. The chairs were initially numbered in the 1860s, and the practice continued until the chair industry was closed in 1942.

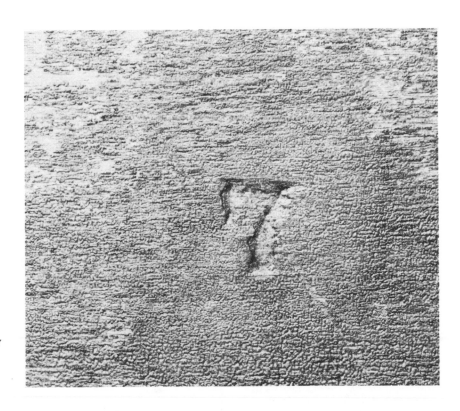

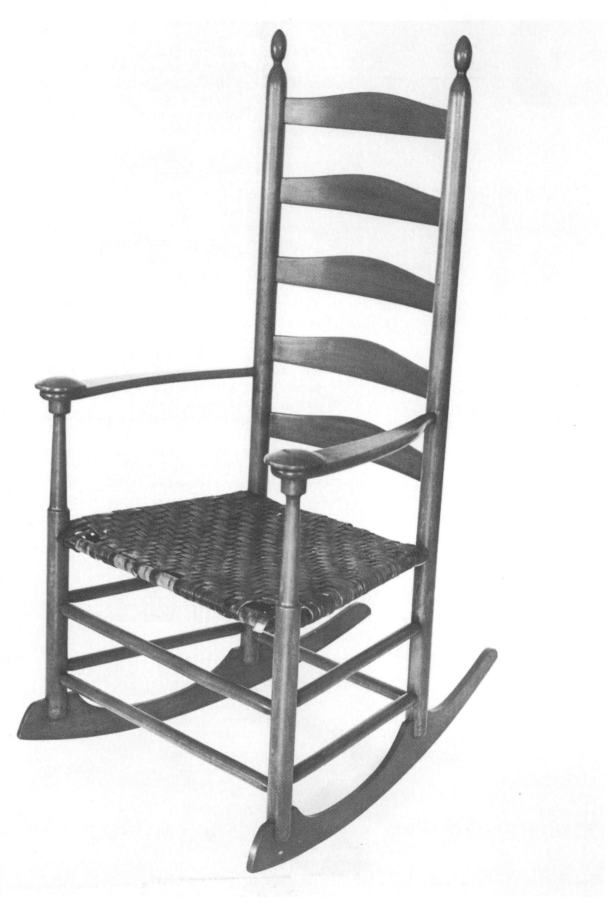

Five-slat rocking chair, Mount
Lebanon, New York, late nineteenth
century, uncommon form.

The back posts of the production chairs taper to the acorn-shaped finials.

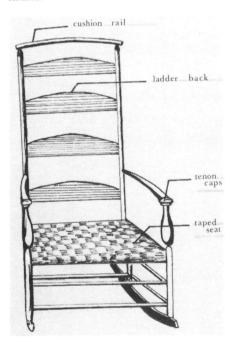

cushion rail

ladder back

tenon caps

taped seat

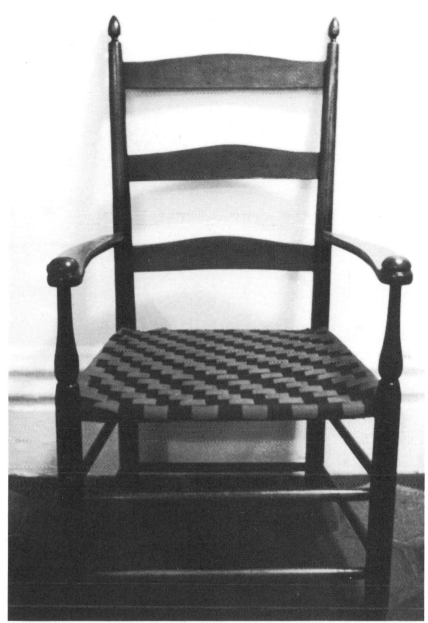

#1 production rocking chair, Mount Lebanon, late nineteenth century.

Stamped or impressed "1" in back of top slat.

5

Boxes and Carriers

As the interest in Shaker antiques grows, we see refinished oak rocking chairs and early twentieth-century butter paddles from the pages of Sears Roebuck and Company catalogs marked and priced as "Shaker." If a box is oval or warped and "out of round," it is "Shaker."

Several years ago an area antiques dealer advertised that she would appraise any "old article" brought to her for $3. It made no difference if it was Pilgrim century furniture, Depression glass, stock certificates, or Mr. Peanut jars, she would authenticate and evaluate. We sent a friend to her booth at a shopping mall antiques show with a painted oval box with fingers. The antiques dealer immediately recognized the box and officially declared it to be a "Quaker" box. When asked if the value of the box would be enhanced if the paint were removed to allow the wood grain to show through, she remarked, "If it was mine, it would have been stripped yesterday."

In the early 1970s painted Shaker boxes were commonly offered for $100–$250. In 1983 a box sold for more than $8,000 at a New England auction.

Today the value of a Shaker oval box is in direct proportion to the degree of desire an individual has to own it. If a box turns up that is the precise color and size a collector needs to complete a stack that has been a decade in the making, financial caution is often punted recklessly to at least three of the four winds.

Uncommon Alfred stamp from bottom of oval carrier.

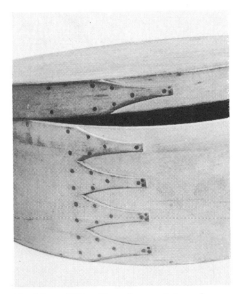

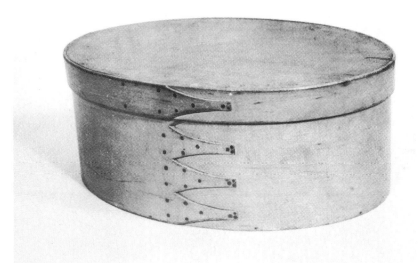

Oval box 11" with ochre paint and initials "P.C." in red paint.

"P.C." painted on the side of the ochre oval box.

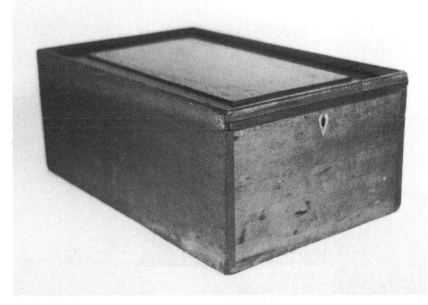

Slide top box. Constructed in 1866 of cherry with a red "wash," this slide lid storage box is a product of the Enfield, Connecticut, Shaker community. It is 7" high, 10½" wide, and 16" deep. (Miller Collection)

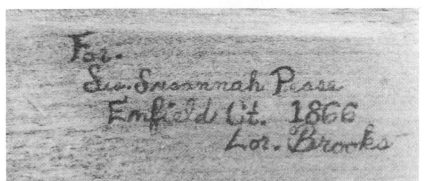

An inscription on the box reads "For Sis. Susannah Pease/Enfield Ct. 1866/ Lor. Brooks."

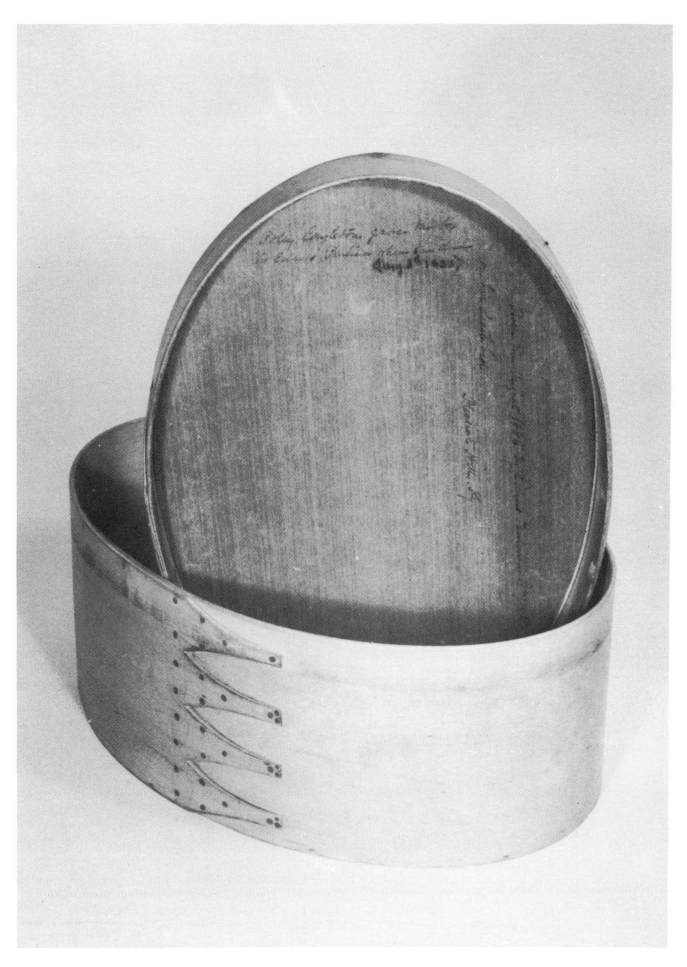

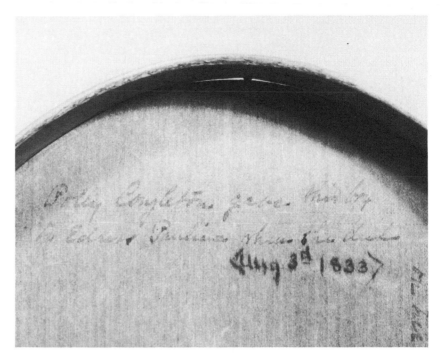

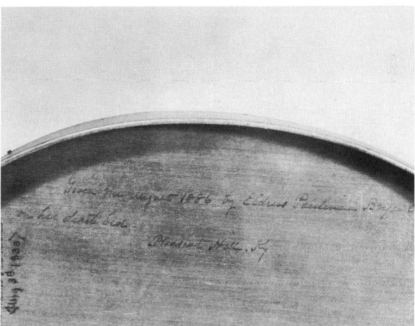

The bottom of the pine lid traces the history of the box from August, 1833, when it was given by Polly Congleton to Pauline Bryant. Eldress Bryant passed the box along on her deathbed in August, 1886, to an unnamed third party.

There are several key variables that can determine the value of an oval box. These include:

Condition,
Provenance,
Finish or color,
Quality of workmanship,
Size,
Number of fingers or lappers,
Emotional and financial condition of the potential buyer.

At the 1984 Duxbury, Massachusetts, auction there was a wide variation in the prices paid for oval boxes. A stack of six boxes in dark green paint brought $1,600 (pre-sale estimate of $6,500–$8,500). A graduated stack of three other dark green boxes brought $2,200 (pre-sale estimate of $4,000–$5,000).

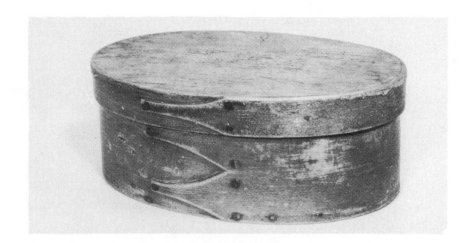

Blue green 6″ oval box.

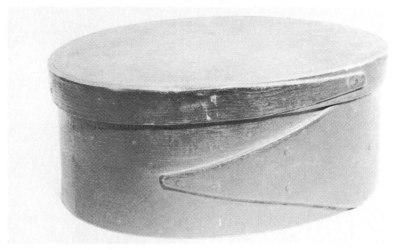

Green 6½″ oval box with "Harvard-type" fingers.

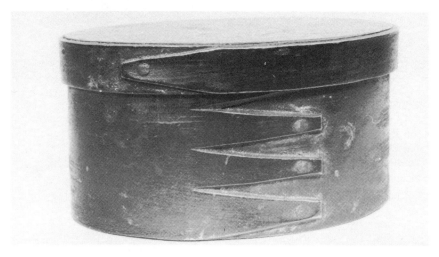

Dark brown 4½″ oval box.

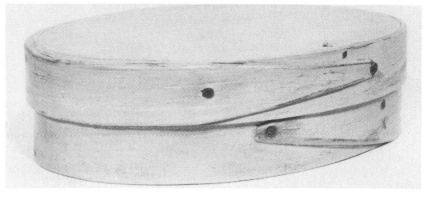

Oval box 5″ with ochre (yellow) paint.

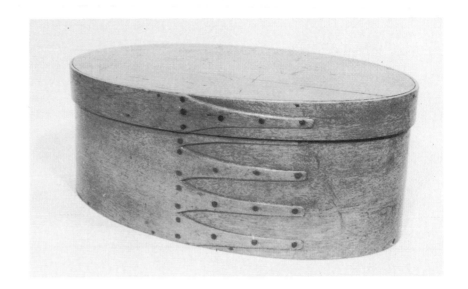

Bittersweet 8″ oval box with exceptionally graceful fingers or "lappers."

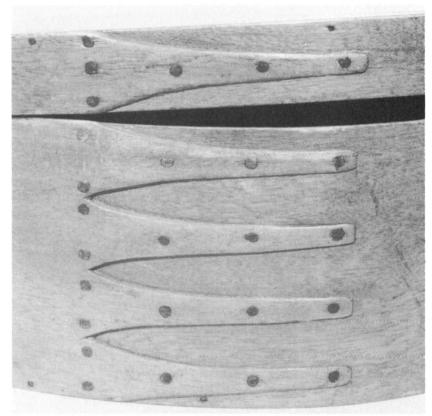

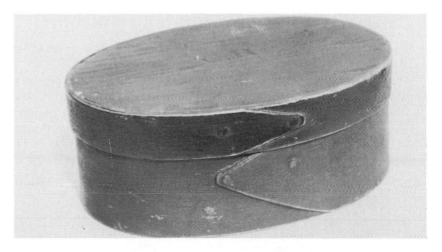

Green box 5″ with "Harvard-type" fingers.

The prices on the four boxes listed below were more in keeping with their pre-sale estimates.

Four-fingered oval box, lipstick red paint, 6½″ long	$3,630
Five-fingered oval box, red paint, 17¼″ long	2,750
Four-fingered oval box, yellow paint, 10½″ long	2,970
Three-fingered oval box, red-orange paint, 6″	3,025

Four-figure pricing for two- or three-fingered boxes has not always been the norm. The following prices were paid for oval boxes at a June 20, 1972, widely advertised auction in Maine.

Oval-fingered box, signed Mary Francis Dahm, 9″ x 12½″	$100
Oval-fingered box, old red paint, 9″ x 6″	87.50
Oval-fingered box from Alfred, Maine, 8½″ x 12″	100
Oval-fingered carrier with handle, 8″ x 11″	130

On June 19, 1973, another Maine auction offered several exceptional oval boxes.

Nest of four oval boxes with natural finish	$387.50
Cherry wood oval fingered box, 11″	145
Oval fingered box with a paper label "silk cord," 13½″	165
Oval fingered box 10¼″ x 7″	85
One-half oval box with hinged cover	145

Oval boxes have been made by the Shakers since the late eighteenth century. Mention was made of their use as early as the 1790s. They were made as late as the 1950s by Brother Delmar Wilson (1863–1961), the last male Shaker. The Shakers produced oval boxes longer than any other of the myriad "industries" in which they were involved.

The boxes were sold by the Shakers in their New England communities and also were available at tourist resorts and vacation centers well into the twentieth century.

On November 13, 1981, the collection of William Lassiter was sold in New York City. Some exceptional Shaker boxes and carriers were offered to bidders. They commanded the following prices.

Long carrier, yellow ochre paint, 14½″	$4,200
High spit box, yellow ochre paint, 5″	2,300
Long box with yellow ochre paint, 8¼″	1,600
Long box, reddish-orange color, inscribed "Mary Whitcher Given at New Lebanon 1851, M W," 15″	4,400

In the 1830s the boxes were priced between twenty-five cents and seventy-five cents each depending on size. They were not inexpensive even at that point because a common wage for a working man was often less than one dollar per day.

The boxes were sold individually or in stacks or "nests" of twelve, nine, seven, and five. Like the rocking chairs, the boxes were numbered. A #1 box was the largest oval box the Shakers made. In the early 1830s the #1 boxes sold for $9 a dozen.

On occasion the Shakers produced uncommonly large boxes. An oval box 23″ long and 13″ wide is mentioned in Shaker literature, but it would be extremely difficult to locate a comparable example today.

They were used primarily for storage of pins, dry foods, herbs, and spices. The boxes were made with maple sides and rims, and pine was used for the tops and bottoms. The sides and rims were soaked in hot water or steam-treated to make them pliable. The maple side was then wrapped around an oval wooden mold or "shaper." Copper rivets were added to hold the fingers to the sides of the box. The pine tops and bottoms were each made from a single disk and held to the rims with wooden pegs or tiny iron brads. On some of the later boxes copper rivets were used to secure the rims.

Many of the boxes sold to the "world" were varnished and a small percentage were painted by the Shakers. It was outlined in the Millennial Laws that the boxes owned by the Shakers could be stained red or yellow but not varnished. It was determined that the Shaker brothers and sisters could not keep the varnished boxes for themselves because the shiny finish served no purpose and was "superfluous."

The New England Shakers also made oval boxes and added a "drop" or bail handle to make a carrier. The early carriers had maple sides, a pine bottom, and a hickory handle. The best carriers have "fixed" handles that are secured to the sides by copper rivets. The bottoms were held to the sides with tiny wooden pegs or iron brads.

The "drop" handled carriers often were fitted with silk damask and served as sewing boxes. This form was made well into the twentieth century and could be purchased with lids.

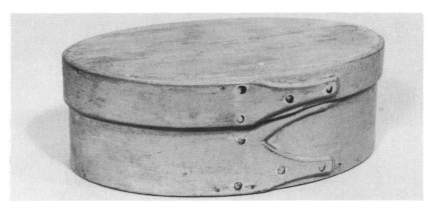

Oval box 6¼" with blue gray paint.

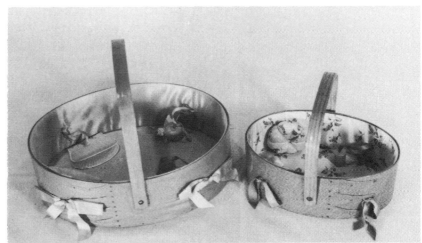

Oval carriers, pincushions, emery, wax and needlecase. The smaller carrier is from Sabbathday Lake, Maine, and the larger example is from Alfred, Maine. Carriers like these were commonly sold in the sisters' shops. (Miller Collection)

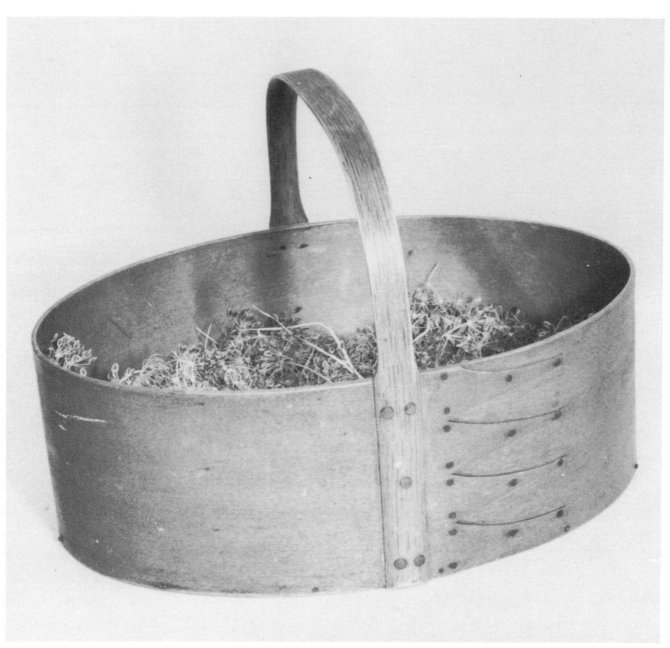

Carrier 11″ with fixed handle.

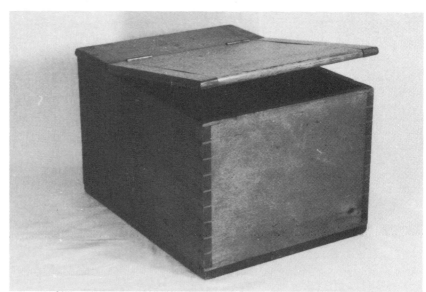

Storage box, pine, dovetailed sides,
hinged lid, breadboard ends to
prevent warping. (Miller Collection)

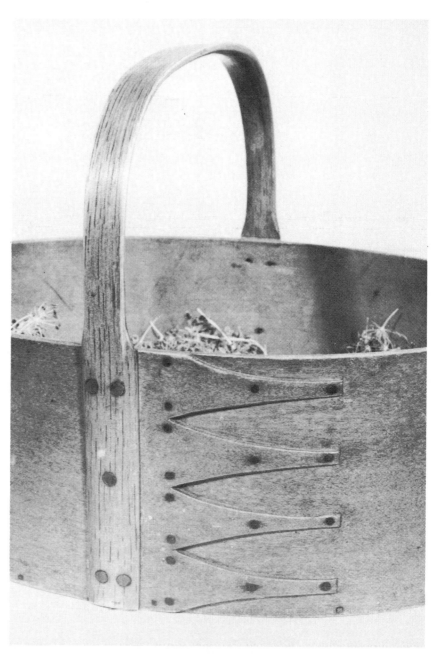

Nineteenth-century carrier with hickory handle.

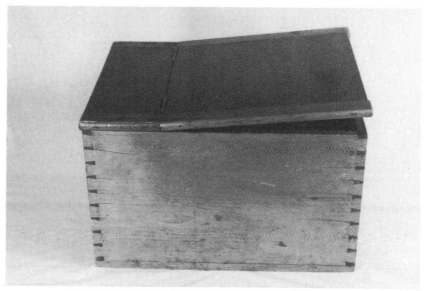

The box is 13¼" wide, 17" deep, and 11¼" high. Inside the hinged lid is written "Sadie A. Neale Her Box."

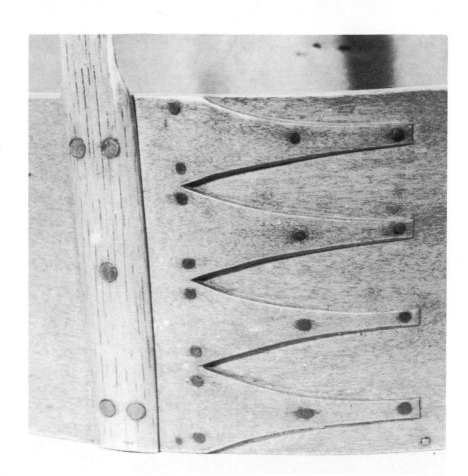

The carriers were constructed in exactly the same manner as the boxes with the addition of a hickory handle.

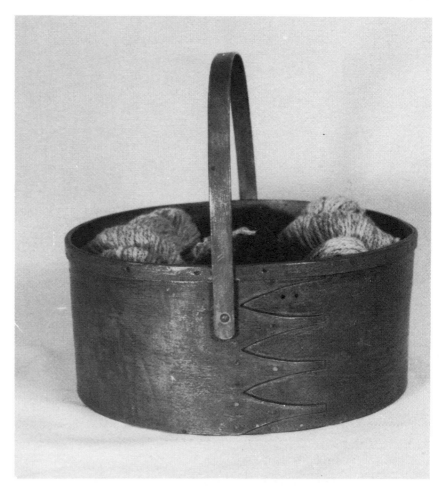

Round handled carrier, four fingers, reinforced rim and ash handle, Watervliet, New York, orange paint and lacquer finish, 11½" diameter. This round carrier was probably converted from a more common spit box. Few examples of this form exist. (Miller Collection)

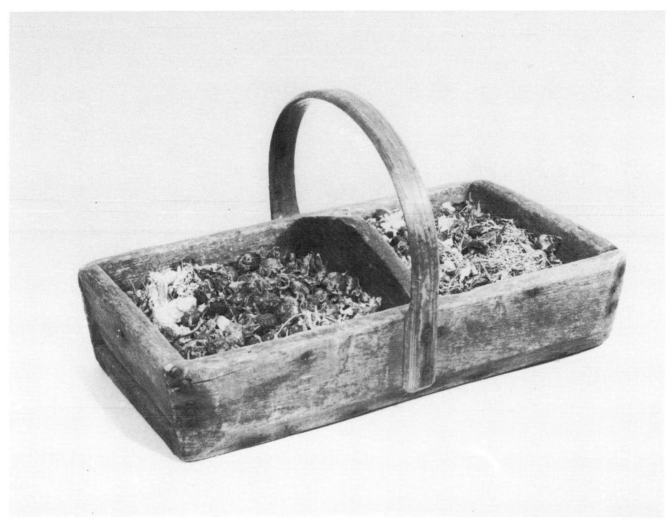

The sides of the rectangular carrier are held together with "rosehead" nails.

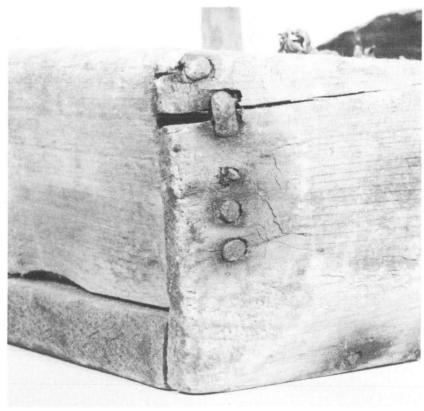

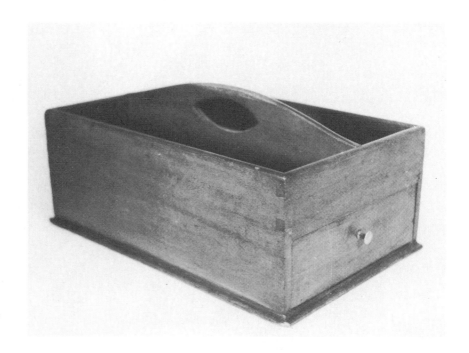

Tool carrier, cherry wood that is
stained red and covered with varnish,
probably from New Lebanon,
commercially made brass knob. (Miller
Collection)

6

Shaker Seed Industry

The New Lebanon and Watervliet Shakers were the first to enter the seed business on a commercial scale in about 1790. Communities in Hancock, Massachusetts, and Sabbathday Lake, Maine, eventually followed. Initially, flax seed was the biggest seller but cucumber, lettuce, and onion seed soon became almost as popular.

The communities operated their seed business on an individual basis until 1819. At that time Shakers from Hancock, Watervliet, and New Lebanon met and agreed that no single group should buy seeds from the "world" and mix them with locally grown seeds.

The Shaker seed salesmen made a trip by horse-drawn wagon each spring to deliver seed boxes filled with their product to stores in the area surrounding their community. The fall trip to pick up the unsold seeds allowed the Shakers to settle their accounts with the storekeepers. This arrangement was unique with the Shakers. They were among the first to do business on consignment. They provided the display box and seed packets or "papers" and allowed the store to keep approximately one-third of the proceeds from the sale of the seeds.

Several New England Shaker communities and the New Lebanon, New York, colony produced garden manuals and seed catalogs as early as the 1830s. The manuals gave advice on growing conditions and gardening techniques and were highly successful. The manuals sold for six cents and provided the Shakers with a steady source of income for many years. The catalogs and manuals are now eagerly sought by Shaker collectors and are difficult to find even though they were sold by the thousands in the nineteenth century.

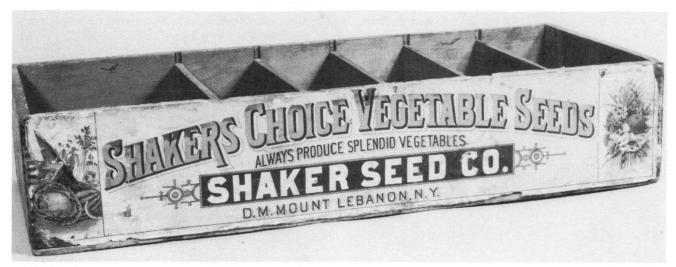

This Mount Lebanon box has an unusually ornate paper label on its exterior and dates from about 1885. It almost always turns up without its lid.

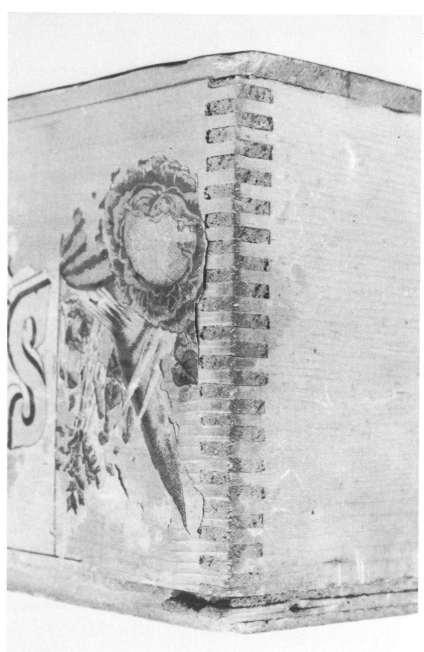

Machine dovetails on late Mount Lebanon box. The majority of the seed boxes were nailed together rather than hand- or machine-dovetailed.

The majority of the seed boxes that collectors are finding today date from the 1870–1890 period. The Shakers began to face serious competition for business after the Civil War from major New England and Midwestern growers.

The growing competition from the "world" and the decreasing membership of most New England Shaker communities brought an end to the seed operations by about 1890.

In 1850 there were five to six thousand Shakers in nineteen communities from Maine to Kentucky. In 1900 there were fewer than one thousand Shakers on the membership rolls of a steadily declining number of communities. The Shaker seed growers were forced to go into the "world" and hire workers to assist them.

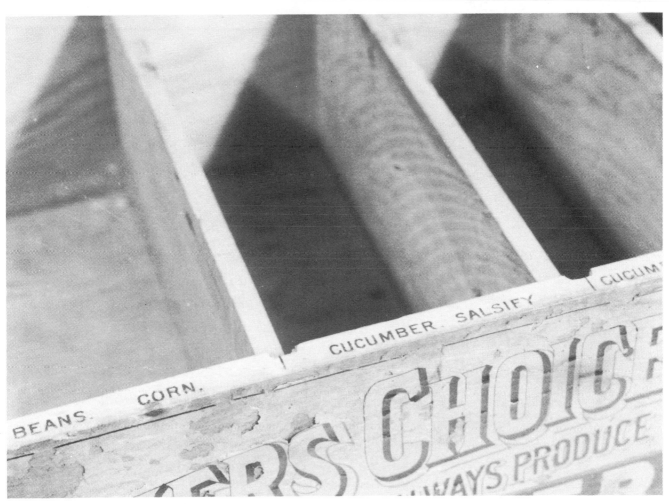

Interior of seed box showing dividers and seed sections.

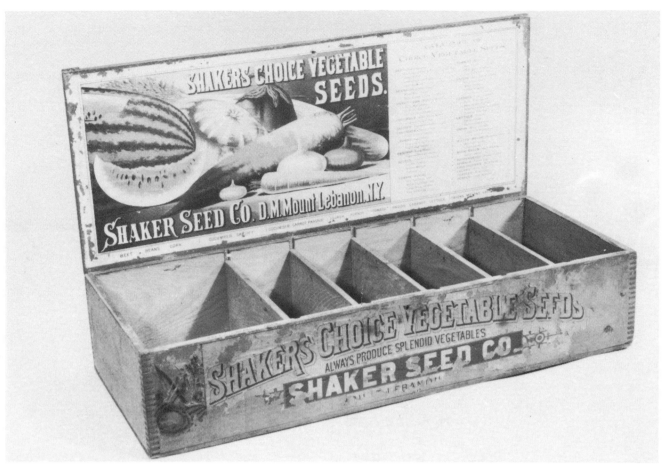

Rare Mount Lebanon seed box with its
original lid and interior label.

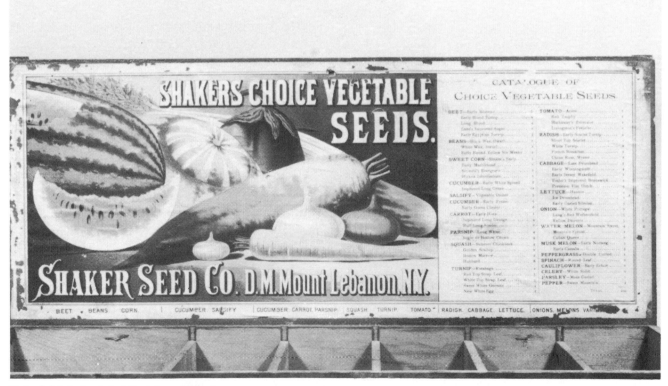

Colorful interior label that invariably is
removed from its box.

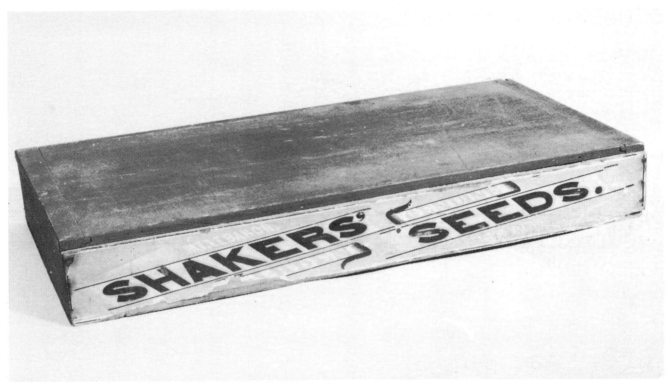

Mount Lebanon box from the 1880s.

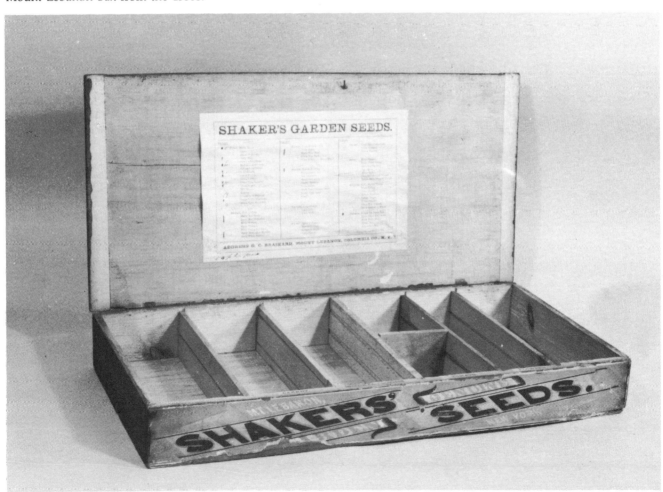

Interior of the box showing dividers
and simple paper label that lists the
contents of the box.

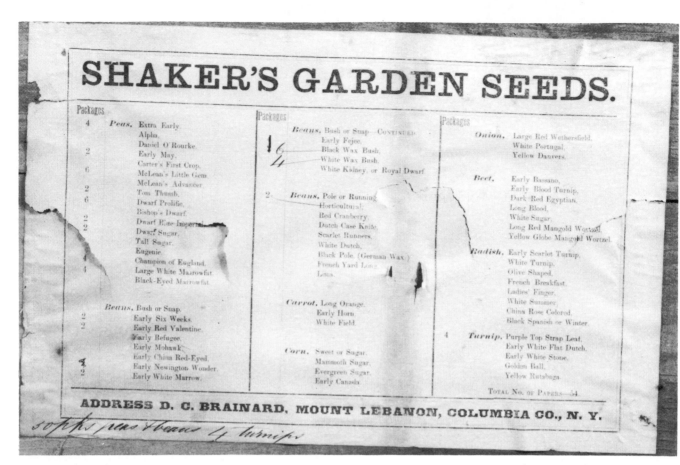

SHAKER'S GARDEN SEEDS.

Packages			Packages			Packages		
4	**Peas,**	Extra Early.		**Beans,**	Bush or Snap—CONTINUED.		**Onion,**	Large Red Wethersfield.
		Alpha.			Early Fejee.			White Portugal.
		Daniel O'Rourke.	6		Black Wax Bush.			Yellow Danvers.
2		Early May.	4		White Wax Bush.			
6		Carter's First Crop.			White Kidney, or Royal Dwarf		**Beet,**	Early Bassano.
		McLean's Little Gem.						Early Blood Turnip.
2		McLean's Advancer.						Dark-Red Egyptian.
6		Tom Thumb.	2	**Beans,**	Pole or Running.			Long Blood.
		Dwarf Prolific.			Horticultural.			White Sugar.
12		Bishop's Dwarf.			Red Cranberry.			Long Red Mangold Wortzel.
		Dwarf Elite Imperial.			Dutch Case Knife.			Yellow Globe Mangold Wortzel.
		Dwarf Sugar.			Scarlet Runners.			
		Tall Sugar.			White Dutch.		**Radish,**	Early Scarlet Turnip.
		Eugenie.			Black Pole. (German Wax.)			White Turnip.
4		Champion of England.			French Yard Long.			Olive Shaped.
		Large White Marrowfat.			Lima.			French Breakfast.
4		Black-Eyed Marrowfat.						Ladies' Finger.
								White Summer.
				Carrot,	Long Orange.			China Rose Colored.
	Beans,	Bush or Snap.			Early Horn.			Black Spanish or Winter.
12		Early Six Weeks.			White Field.			
		Early Red Valentine.				4	**Turnip,**	Purple Top Strap Leaf.
		Early Refugee.						Early White Flat Dutch.
		Early Mohawk.		**Corn,**	Sweet or Sugar.			Early White Stone.
		Early China Red-Eyed.			Mammoth Sugar.			Golden Ball.
12 4		Early Newington Wonder.			Evergreen Sugar.			Yellow Rutabaga.
		Early White Marrow.			Early Canada.			

TOTAL No. OF PAPERS—54.

ADDRESS D. C. BRAINARD, MOUNT LEBANON, COLUMBIA CO., N. Y.

50 pks peas & beans 4 turnips

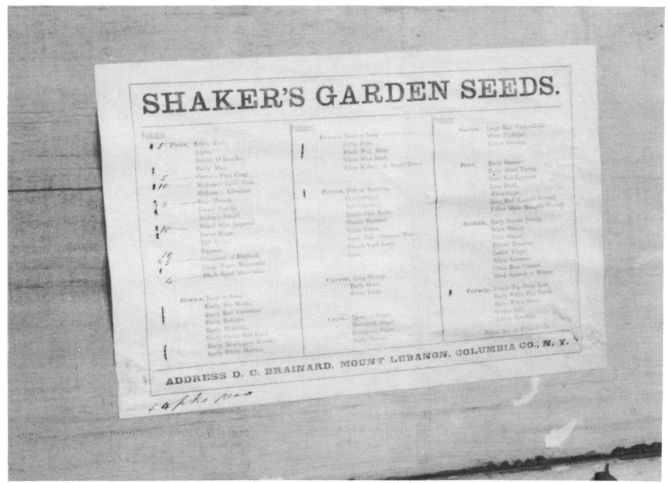

Notes on Collecting Shaker Seed Boxes

The most commonly found boxes are products of the Mount Lebanon, New York, community.

A New Lebanon, New York, seed box pre-dates 1861.

The typical seed box was constructed of pine, nailed together, painted or stained a deep red, had a rectangular paper label on the front of the box, and an interior label that listed the variety of seeds it held. The hinges were made of leather and tacked to the top and back of the box on a variation of the cotter pin.

A rare box from Enfield, New Hampshire (c. 1840s), had a stenciled front rather than a paper label, an iron lock, dovetailed sides, and leather hinges.

In the 1880s many Mount Lebanon boxes were also stenciled rather than paper labeled.

It is extremely difficult to locate a box with both interior and exterior paper labels. Typically the interior label has been peeled off or badly ripped and the exterior label has some damage.

Collectors should not expect to find a seed box in pristine condition. Labels become brittle over time and chip away. When the boxes were returned each fall, they were repainted or repaired and new labels were glued over the old labels.

Shaker Seed Industry Chronology

1790s (Early) Seeds were being sold in Watervliet, New York, and New Lebanon

1794 Garden seed "industry" begins at New Lebanon on a large scale

1800 Flax seed is initially the biggest seller

1819 Hancock, Watervliet, and New Lebanon gardeners agree to sell only seeds grown by the Shakers

1836 Charles Crossman's first gardener's manual (16,000 copies) is issued and sold for 6¢ by New Lebanon Shakers

1843 "Plain Instruction for the Selection, Preparation, and Management of a Kitchen Garden" is published at New Lebanon

1861 Post office change in New Lebanon. After 1861 the community was called Mount Lebanon, which changed the name on the seed boxes and now provides a manner of dating

1870s Gradual decline in demand for Shaker-grown seeds due to increasing competition from national companies

1880s Shakers try to stimulate business by advertising in popular magazines and newspapers

1890s (Early) The Mount Lebanon Shakers close the seed industry due to significant financial losses and falling membership.

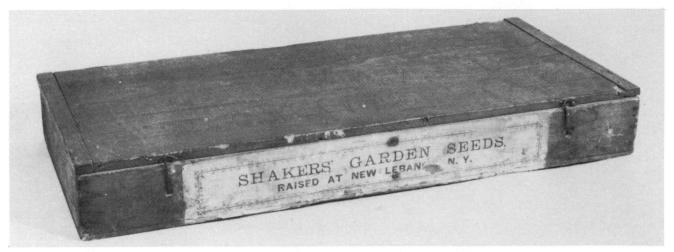

A post office change at New Lebanon in 1861 provides a reasonably precise method to determine if seed boxes pre-date that point. New Lebanon boxes are much more difficult to locate than the more commonly found Mount Lebanon boxes.

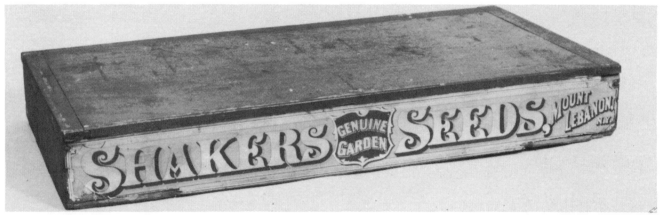

Mount Lebanon box, c. 1880.

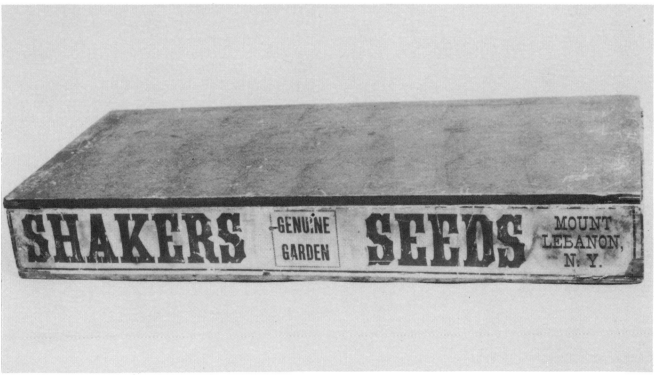

Mount Lebanon box, c. 1870s.

Pine seed boxes with paper label, c. late 1850s.

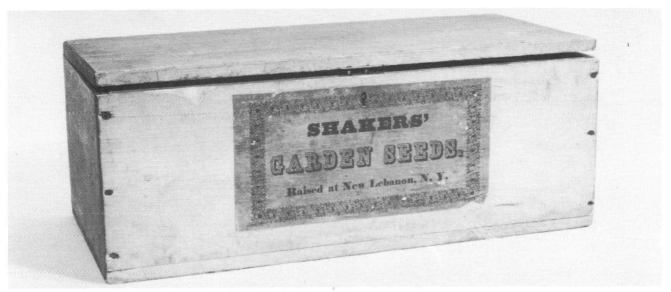

New Lebanon boxes are rarely found with locks. This example of pine with nailed corners is an exception.

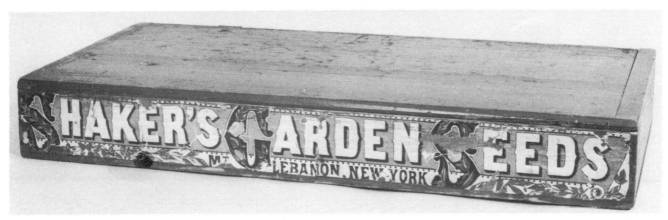

Mount Lebanon box, mid-1880s.

Grain painted top of Mount Lebanon box.

The boxes are usually found with leather hinges or a Shaker variation of the Pilgrim cotter pin. This leather hinge was easily replaced if it was torn or dried out and split.

68

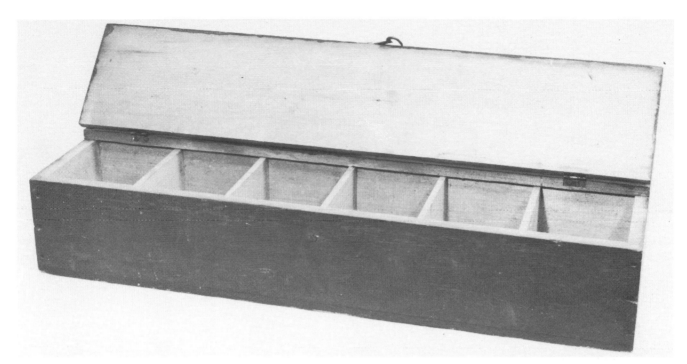

Alfred, Maine, seed box, navy blue paint, pine, c. 1880, twelve compartments and two hinged lids.

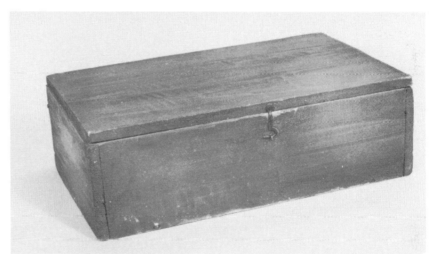

South Union, Kentucky, seed box, c. 1870.

"SO. SHAKER" stenciled onto the bottom of the pine box. Very few South Union boxes with their labels intact are known. This box never had paper interior or exterior labels and was found in a shop in Kentucky filled with postcards. It has a red "wash" and was nailed together.

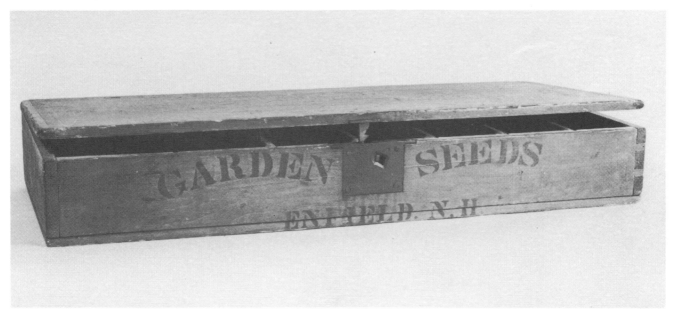

Enfield, New Hampshire, seed box, c. 1850s, pine, stenciled front, iron lock.

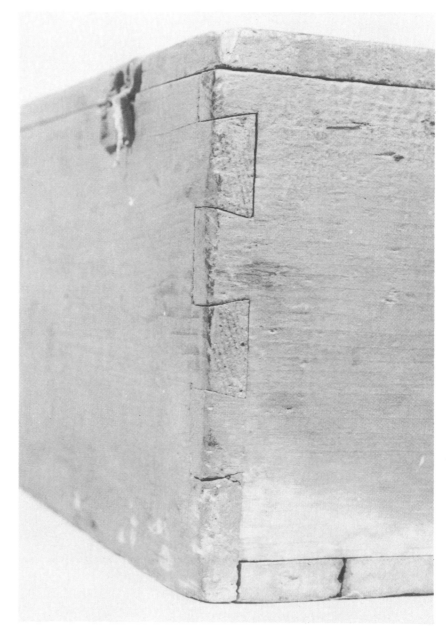

The Enfield box was hand-dovetailed.

70

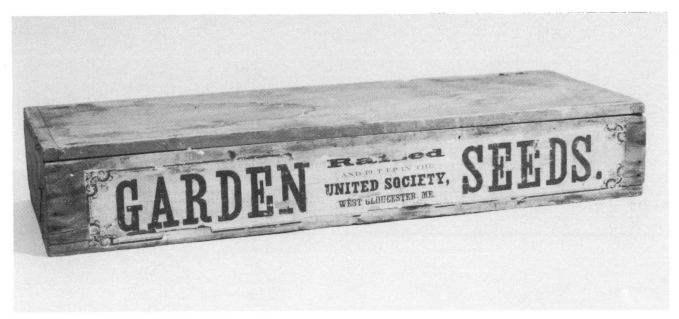

West Gloucester (Sabbathday Lake),
Maine, seed box, c. 1870s.

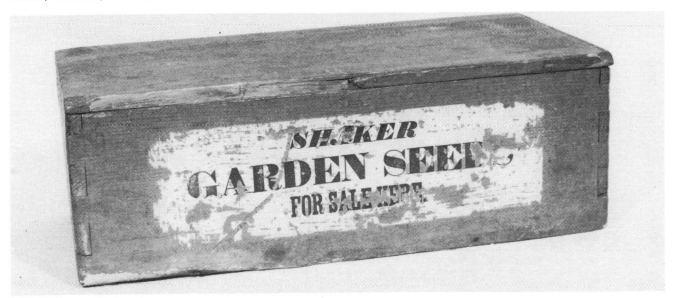

Shaker seed box made from pine, red
wash, hand-dovetailed, c. 1850s,
probably from New Lebanon.

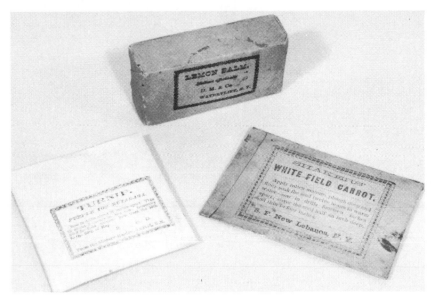

Seed "papers" from Enfield, New
Hampshire, and New Lebanon, c.
1850s, packet of lemon balm herbs
from Watervliet, New York.

Reverse of seed "paper" with penciled "64" that shows the year of "growth" for the contents.

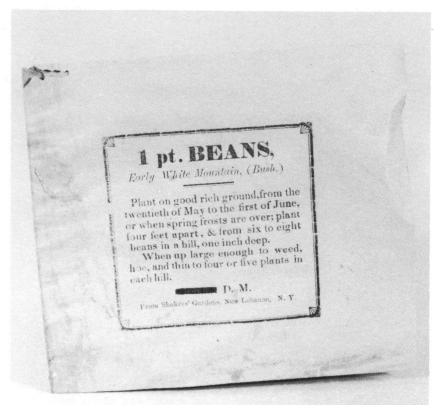

Seed "paper" from New Lebanon.

Burlap seed sack from Enfield, New Hampshire. The "C H H" refers to the Church Family, the senior order at each of the Shaker communities. (Miller Collection)

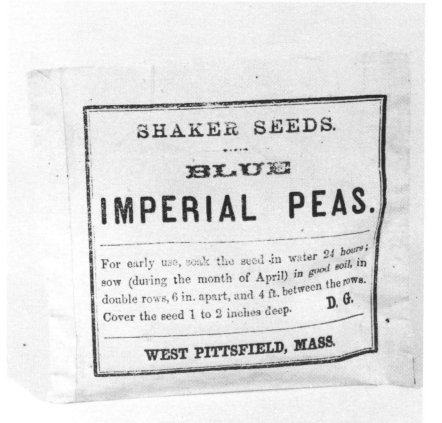

Seed "paper" from West Pittsfield (Hancock), Massachusetts.

This counterfeit was duplicated on old paper. In recent years, as the market for Shaker ephemera has grown, counterfeits have become a legitimate concern for collectors.

7

Fancy Goods

In the years immediately following the Civil War the Shakers found that the "world" had changed a great deal. The war had created hundreds of factories that produced uniforms, weapons, and foodstuffs. After the fighting ceased, the investors, who had bankrolled the industrial development, needed new products to sell. They turned to mass-producing goods previously made by individual craftsmen in rural areas or small towns.

Pottery, furniture, basket, and woodenware factories started to turn out their products in huge quantities at reasonable prices. The growing railroads and mail-order houses brought urban shopping to rural America.

Local craftsmen could not compete. Thousands of families left the farms and moved to midwestern and eastern cities for the plentiful jobs that had been suddenly created. The Shakers' problems were compounded by their falling membership, the increasing complexities of doing business, and their growing inability to be competitive with emerging corporations.

The number of converts to the Shaker way of life fell off dramatically after the war. There were new opportunities for potential members that had not previously existed. The Shakers had offered orphans food, lodging, clothing, and an education. The rise of the factories had brought about jobs that required minimal skills and offered a steady wage.

The Shakers could not adequately maintain their agricultural "industries" because of the falling demand for their products and the decreasing membership. They were forced to turn to new types of products to offer to the "world."

Alfred, Maine, trademark from bureau boxes.

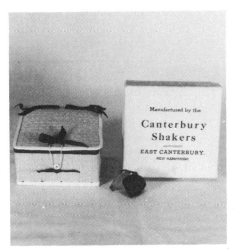

Poplar box lined in royal blue satin and original cardboard container from Canterbury, New Hampshire. (Miller Collection)

The 1870–1900 period brought incredible change to the American consumer. Popular books and magazines shaped styles in home decorating, food, and dress. Victorian Era decorators dictated that homemakers mix "bric-a-brac" with heavily carved walnut and oak furniture.

The New England Shakers began to make "fancy goods" for the "world's" consumers from about 1880 to the early 1930s. These included:

table mats	needle books	postcards
doll bonnets	palm leaf baskets	calling card trays
pincushions	cakes of wax	Shaker-dressed dolls
wool dusters	sweaters	spool stands
chairs	aprons	bookmarks
coat hangers	bonnets	cloaks
rugs		

The Shaker sisters did most of the work in producing the "fancy goods" and sold them from booths at county fairs, resort hotels, and in their own community shops for tourists and local visitors. Many things were sold at department stores in Boston (Jordan Marsh) and Chicago (Marshall Field's).

The Shaker booth at Old Orchard Beach, Maine, was an especially lucrative outlet up to 1920 for "fancy goods," postcards, and fudge.

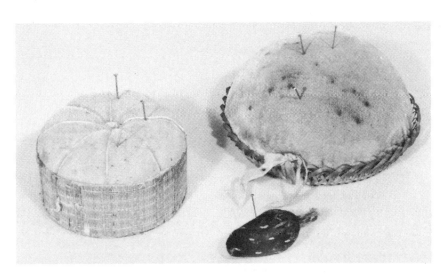

Woven poplar pincushions, c. 1900.

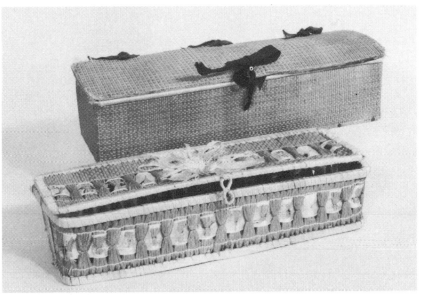

Bureau boxes, c. early 1900s.

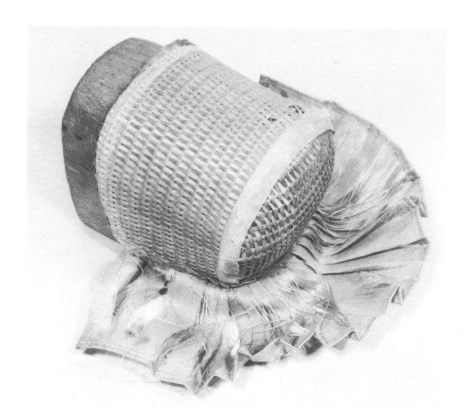

Woven poplar doll's bonnet on pine mold.

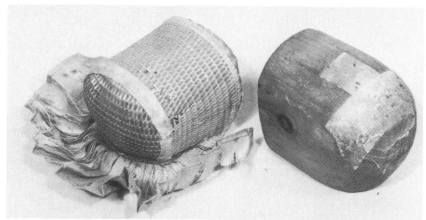

The Shakers purchased the dolls from the "world," dressed them, made the poplar bonnets, and sold them in the sisters' shops in many of the New England communities.

Heavy woolen stockings in dark green.

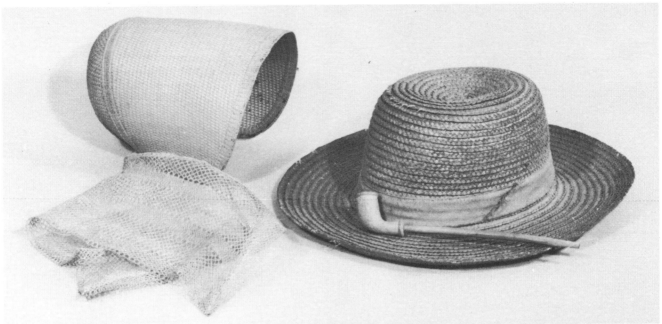

Woven bonnet, summer bonnet, clay
pipe, and Shaker brother's hat, c. late
nineteenth century.

The interior of the woven bonnet
shows the size "4" on a paper label
glued to rear.

Cross-section of early 1900s Shaker sewing articles produced for the "world." The strawberry was filled with ground pumice and used for sharpening needles.

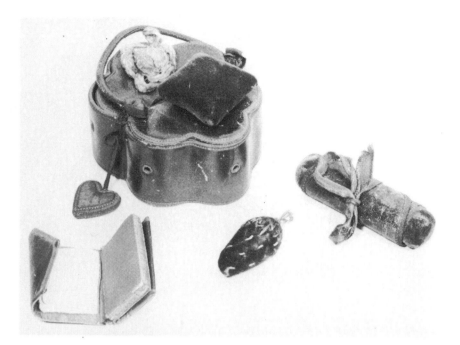

Maple clothes hanger and leather sewing kit.

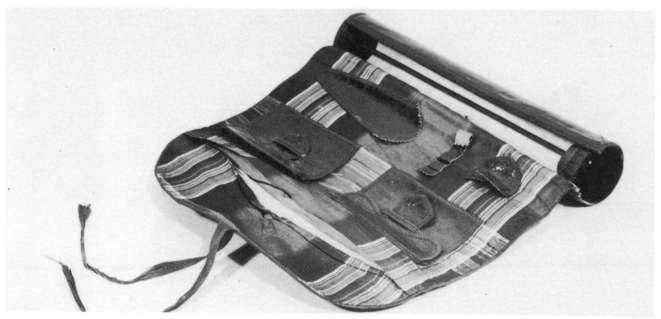

Interior of the leather sewing kit.

78

8

Miscellaneous Industries

The amount of products made and sold by Shakers from the late 1700s until well into the twentieth century is staggering. The list that follows is far from complete.

apple butter	maple sugar
apples	maple syrup
applesauce	medicines
baskets	metal pens
brooms	milk
brushes	maps
candy	oval boxes
carpet whips	pails and buckets
carriers	palm leaf and straw bonnets
catsup	pickles
chair mats and cushions	pills
chairs	popcorn
cheese	preserves and jellies
cider	rosewater
clay pipes	rugs
cloaks	sausages
dolls	shirts
dried pumpkin	shoe buckles
dried sweet corn	shoes
eggs	sieves
fruit	silk handkerchiefs
fudge	spinning wheels
fur gloves	spool stands
garden seeds	straw, felt, and fur hats
herbs	stools
honey	swifts
horsewhips	wine
keelers	wooden dippers
leather goods	

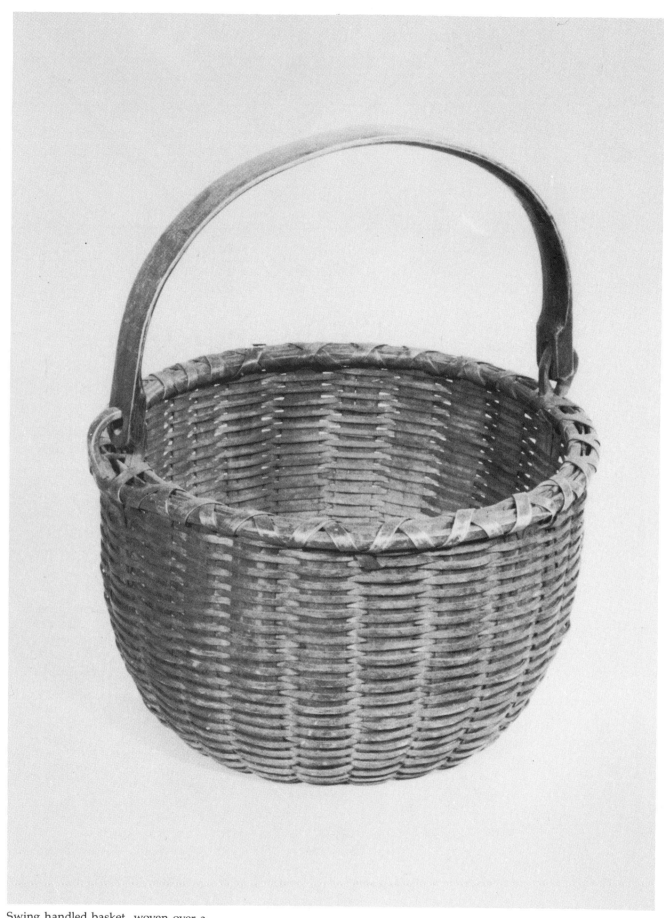

Swing handled basket, woven over a
mold, 11″ diameter, ash splint.

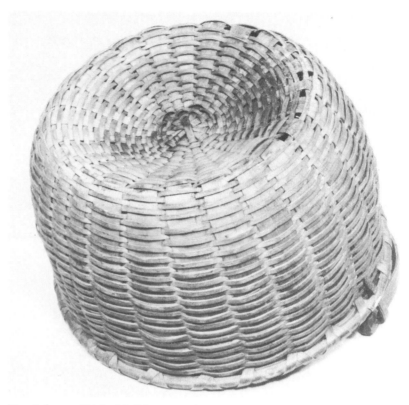

The bow is notched to the basket rim. The rim is bound or lashed with hickory splint.

Demijohn or "kicked-in" bottom of swing handled basket.

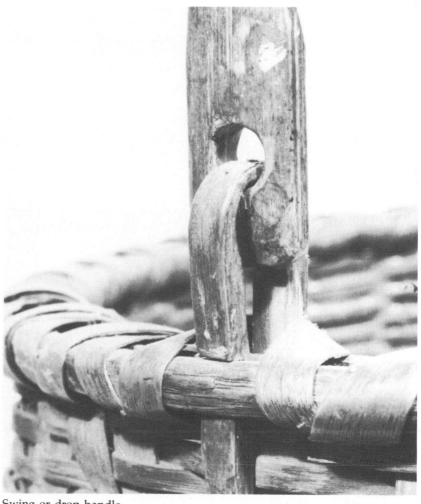

Swing or drop handle.

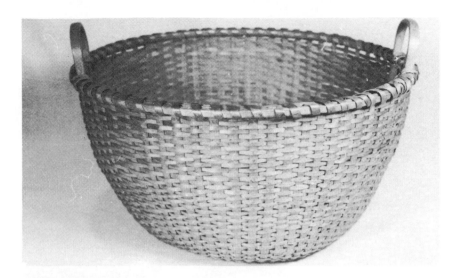

Two-handled basket from Sabbathday Lake, Maine, uncommon herringbone weave. (Miller Collection)

The reinforced bottom of the basket is signed "Prudence A. Stickney."

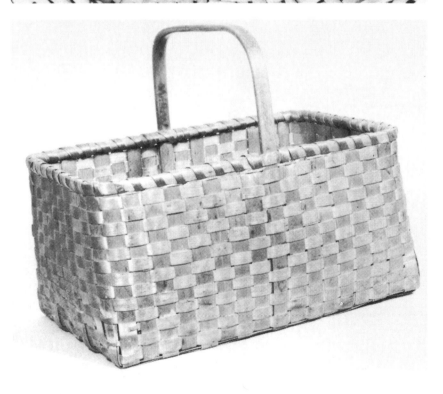

"Carrier" basket used for general utility, white oak splint, initialed "M S W" on inside of handle.

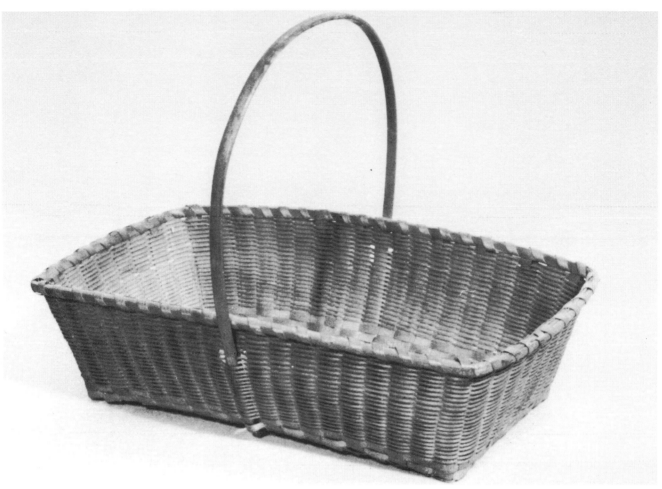

"Fancy" basket, sold in the sisters' shops in early twentieth century.

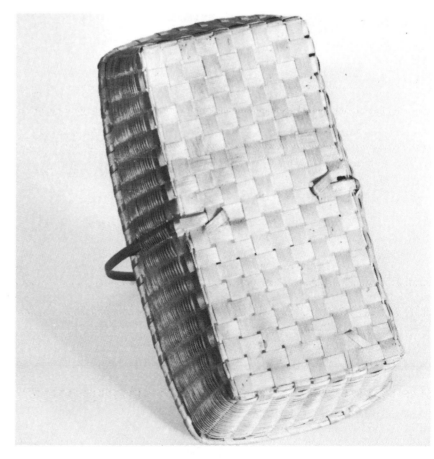

The "filled bottom" of this basket was designed to keep pins and other items from falling through when the basket was picked up.

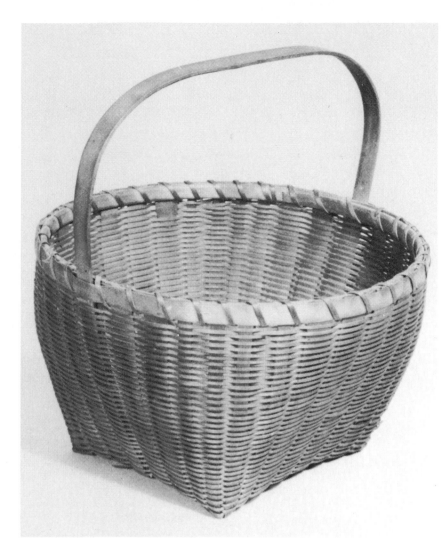

"Fancy" basket, finely woven ash splint, raised bottom, single wrapped rim, c. early twentieth century, New England.

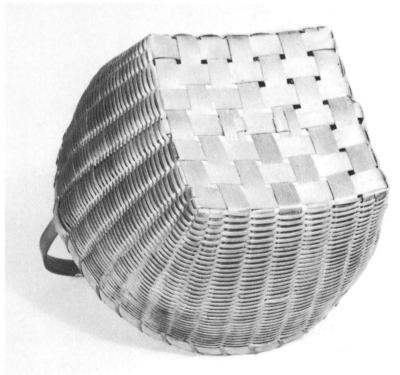

Checkerboard weaving pattern that was "laid loose" rather than tightly woven or "filled."

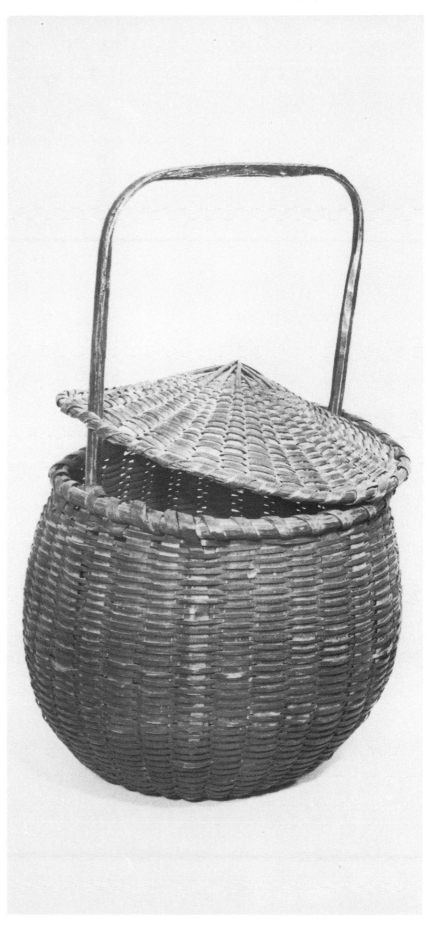

"Feather" type basket with a slide lid, painted a dark green, bulbous form.

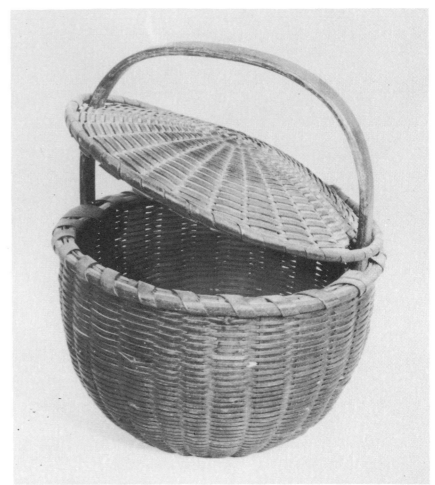

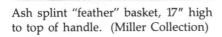

Ash splint "feather" basket, 17" high to top of handle. (Miller Collection)

Ash splint "feather" basket, woven over a mold, single lashed or wrapped rim, stained a deep brown.

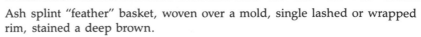

"Harvard" impressed or stamped into top of cheese box cover.

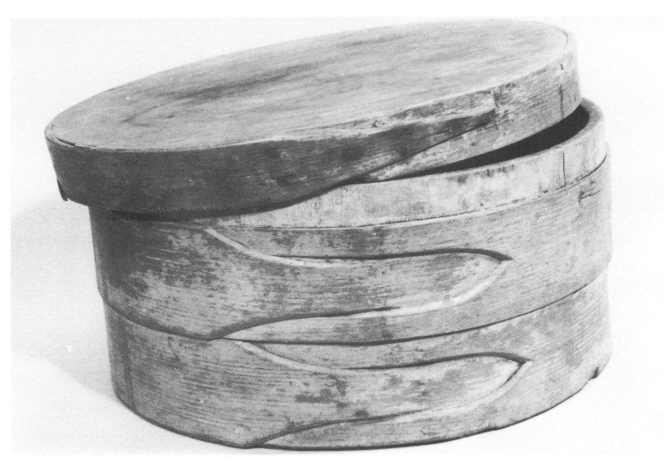

Cheese box, 14″ diameter, painted yellow, "buttonhole" hoop construction, staved pine, Harvard, Massachusetts.

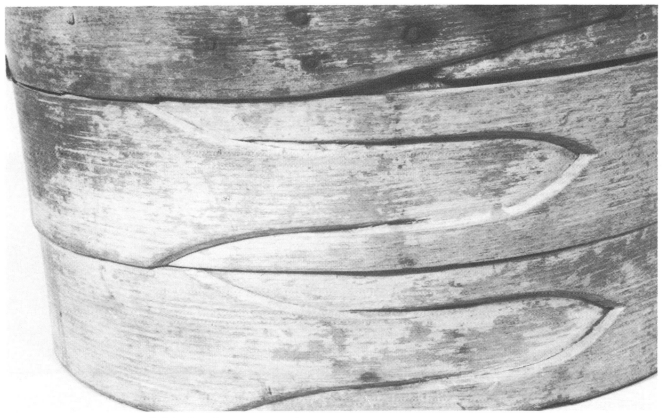

"Buttonhole" construction holds the pine staves.

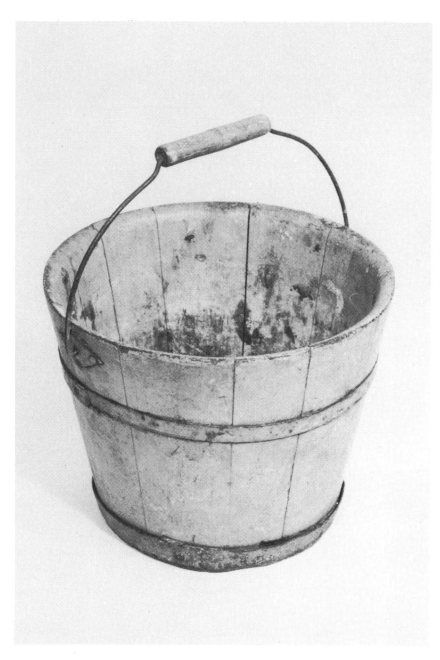

Pail, staved with iron bands, swing or
drop handle, maple grip, 6½"
diameter.

Maple grip or handle with a scribe
mark in the center.

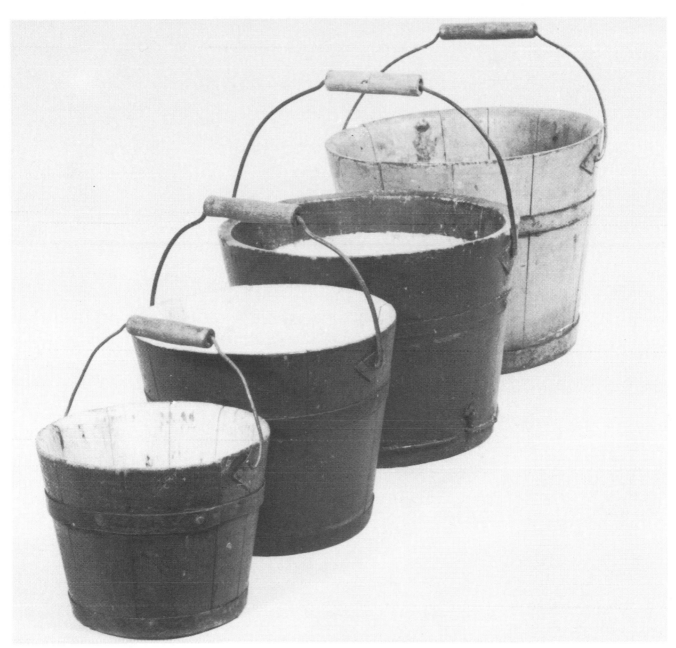

Variety of pails ranging in size from
6½" to 3" in diameter.

Iron "diamond" brace used to support
wire handle. The "diamond" is
commonly found on Shaker-made
buckets and pails.

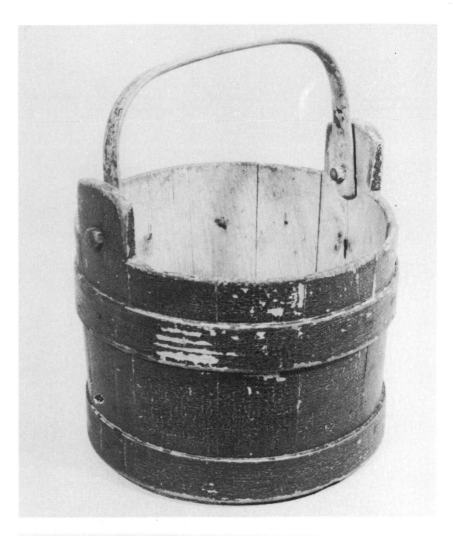

Miniature bucket, pine staves, drop handle, painted green, 7″ diameter.

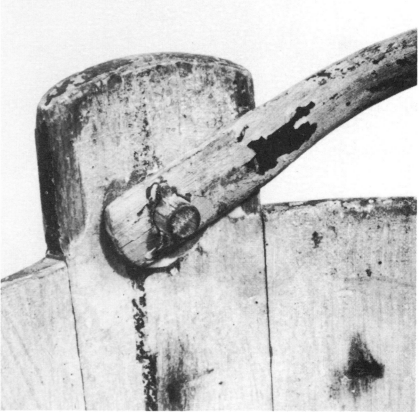

Interior of the bucket and handle pegged and "pinned" to extended stave.

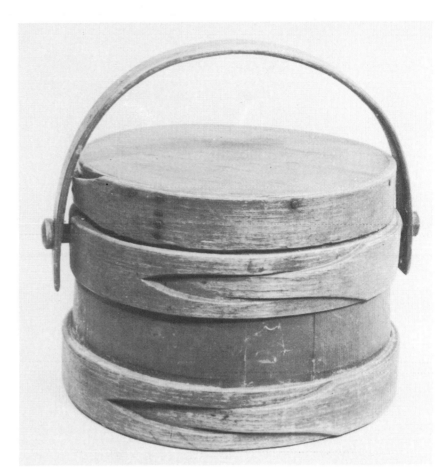

Sugar bucket or firkin, "buttonhole" hoops, staved construction, painted red, drop or swing handle.

Drop handle of the firkin.

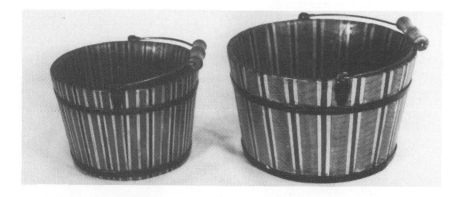

Laminated pails, made by New York Shakers only on special order, more decorative in nature than functional. (Miller Collection)

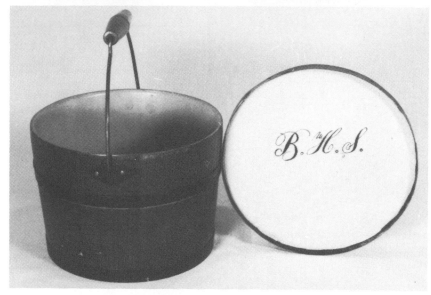

Covered pail, probably made by Canterbury, New Hampshire, Shakers, painted deep red on the exterior and a strong pink on the interior, 8" diameter and 10" high. (Miller Collection)

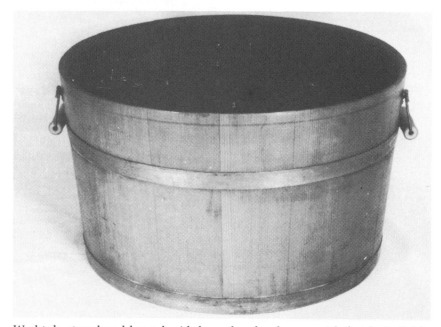

Impressed Shaker mark from Enfield on the bottom of the tub.

Washtub, staved and bound with brass bands, clear varnish finish, Enfield, New Hampshire. (Miller Collection)

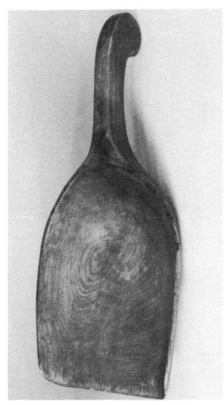

Scoop carved from a single piece of birch, 12″ long. (Miller Collection)

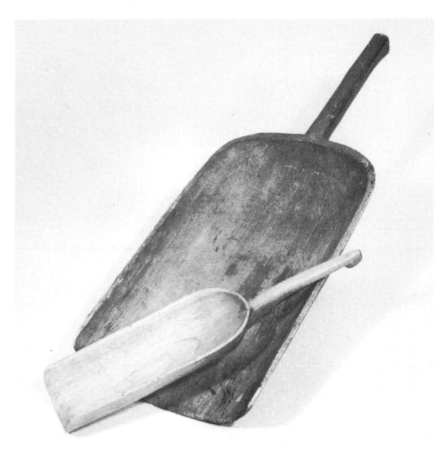

Scoop carved from pine, 6″ long and 11½″ long.

Brush with turned maple head and 5″ long clothespin.

Whiskbroom and dustpan.

Hand mirrors were made in a variety of sizes.

Clay pipes were a production item in several communities in New England and Ohio in the nineteenth century.

94

"Fancy" brushes, turned maple handles, used for dusting, commonly sold in the sisters' shops, early twentieth century.

Variety of Shaker-made brushes produced for the "world."

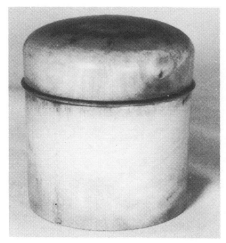

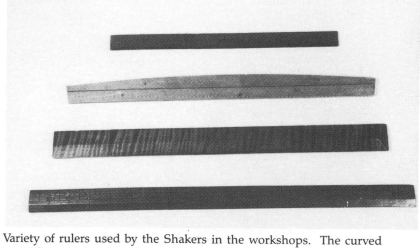

Covered pin box, finely turned maple, almost 3" in diameter, "Caroline Tate" written on the inside of the lid. Caroline Tate was an Enfield, Connecticut, Shaker sister in the late nineteenth century. (Miller Collection)

Variety of rulers used by the Shakers in the workshops. The curved example is made of two connected pieces. The upper portion of the ruler was used in making shoulder yokes on Shaker garments. (Miller Collection)

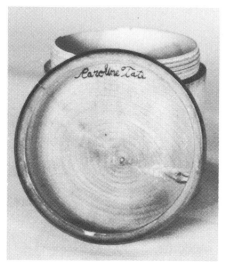

Interior of the lid showing "Caroline Tate."

A close-up of parts of the three rulers that show initials and dates.

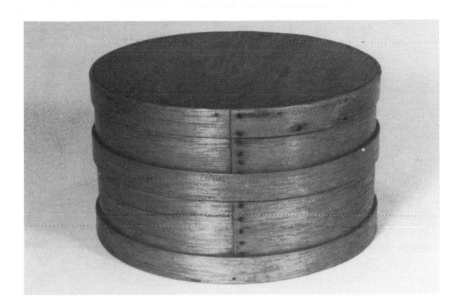

Round sewing box, butternut, 6″ high x 10″ diameter. (Miller Collection)

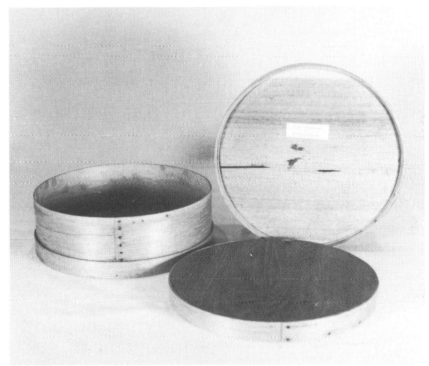

Sewing box consists of two tiers and is made of butternut throughout. The box belonged to Sister Clarissa Jacobs, chief cloak-maker at Mount Lebanon in the last quarter of the nineteenth century.

The concept of individual ownership of property within Shaker communities changed significantly after the 1850s. Prior to that point Sister Clarissa could not have pasted a paper label in the box with her name on it.

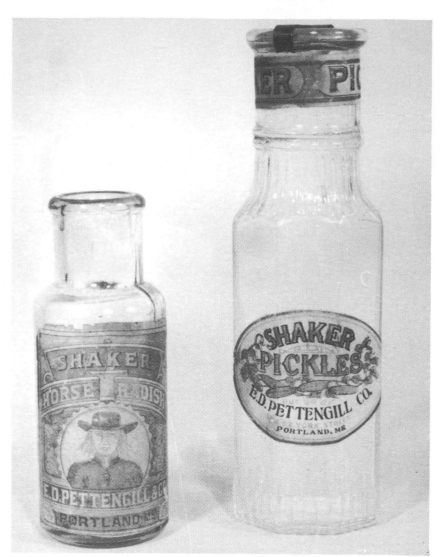

Shaker horseradish and pickles, E.D. Pettengill, Portland, Maine. The pickle bottle contains its original glass cap and tin clasp.

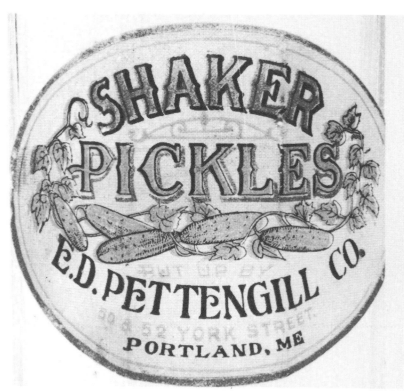

Paper label on Shaker pickle bottle. E.D. Pettengill Co. distributed pickles and ketchup made by the Sabbathday Lake, Maine, Shakers in the early 1900s.

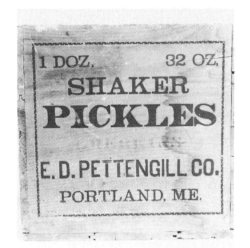

Pettengill Co. packing crate made of pine and designed to hold twelve 32-oz. bottles of pickles.

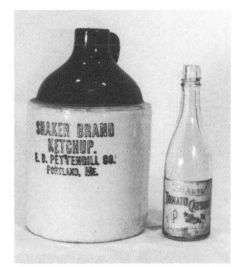

Stoneware ketchup jug with stenciled label and Shaker Tomato Catsup bottle. (Miller Collection)

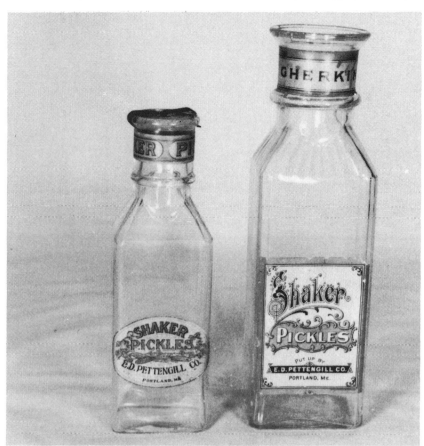

Pickle bottles from Pettengill Co. (Miller Collection)

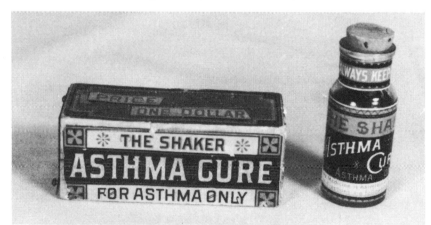

Shaker asthma cure, Mount Lebanon. (Miller Collection)

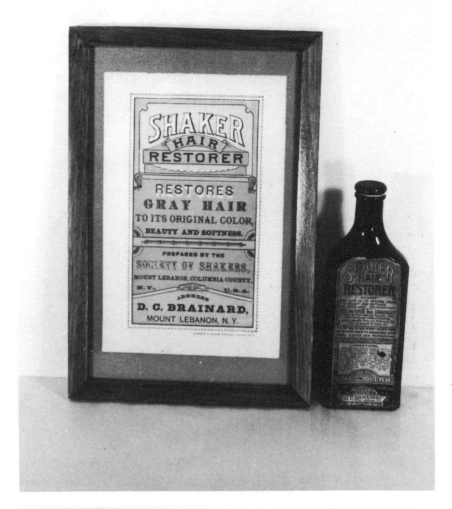

Shaker Hair Restorer bottle and broadsheet. The bottle of Shaker Hair Restorer is amber and embossed. Its label and the framed broadsheet promise that its use "restores gray hair to its original color, beauty, and softness." (Miller Collection)

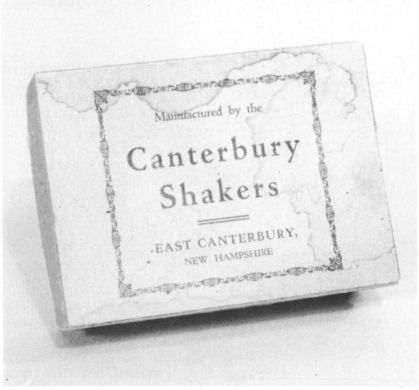

Cardboard box that held candy sold by the Canterbury sisters in their shop for visitors in the early 1900s.

100

9

Shaker Ephemera

This section was developed by David Newell, one of the nation's foremost authorities on the subject of Shaker manuscripts, literature, and ephemera. Mr. Newell was introduced to Shakerism when he stumbled upon a copy of Nordhoff's *Communistic Societies of the United States* when he was a teenager. He was on the staff of the Hancock Shaker Village for several years and is presently a school administrator in western Massachusetts.

In recent years he has bought and sold Shaker literature and ephemera, issuing from one to three catalogs each year. Potential collectors can be placed on the mailing list for a $4 fee. Inquiries should be directed to Mr. Newell at Shaker Literature, R.F.D. Steady Lane, Ashfield, Massachusetts, 01330.

When one considers the great wealth and variety of literature and ephemera published by the Shakers, it is difficult to believe that such a copious quantity of printed works could flow from a sectarian movement that, at its peak of membership, did not exceed 6,000 members. The inventory of Shaker publications is increased further when one adds the hundreds of books authored by those who viewed Shakerism from the "outside looking in." Indeed, the Shakers have commanded the interest and attention of the "world" for two hundred years, and much has been captured in print describing these remarkable people.

Except for a single pamphlet printed in 1790, the Shakers made no use of the press during their first thirty years in America. In the years just prior to 1810, however, the Shakers felt the need to translate the oral testimony of their faith into the written word, and to codify their theology. Many of the great works of Shaker authors date from this period, and for the next one hundred years Shaker pens were busy and the presses ever moving.

Many, if not most, Shaker publications were printed on commercial presses in towns nearby the various societies. The Shakers first experimented with printing about 1812, and that year issued the first bound Shaker work, a hymnal printed at the Hancock society. Other societies obtained presses and by the 1840s, there were several important centers of Shaker printing, the most prolific located at Canterbury, New Gloucester, New Lebanon, Union Village, and Watervliet, Ohio, and to a lesser extent, the two Kentucky societies.

The Shakers have left a varied, interesting, and substantial legacy of printed material, and while many items are rare, there is a wealth of "paper" that has survived, much to the delight of the collector and student alike.

Books and Pamphlets. The earliest Shaker works generally available date from the early 1800s. Quite collectible are many of the theological works of the society. The earlier works are often bound in calf or sheepskin, and some are substantial volumes. *The Testimony of Christ's Second Appearing* and the *Summary View of the Millennial Church* are two important and still available titles from a field of many.

Not to be ignored are the many pamphlets published by the Shakers. During the late 1800s, many were issued from Shaker and commercial presses alike. These pamphlets touch upon all manner of Shaker interests or concerns, from farming to peace, from hygiene to spiritualism. One needs to examine pamphlet contents carefully, as at first glance, it is not apparent that the Shakers published the work.

The rich musical tradition of the Shakers is mirrored in the many hymnals and other works relating to music that they published between 1812 and 1908. Several contain the unusual and unique form of "letteral notation" that substituted letters for the clef notes we are familiar with today. Standard musical notation appears in their hymnals published after 1870.

The great wave of spiritualism, which pervaded all societies after 1837, produced some remarkable bound volumes and pamphlets. These include inspired messages and communications from spirits and departed brethren and sisters. One work, *A Holy, Sacred and Divine Roll and Book* was the first fruit of the Shaker press at Canterbury. This book was distributed to all of the "world's" rulers in the early 1840s in obedience to commands issued from the spirit world.

Strangely, as the membership of the communities began an obvious decline in the late 1800s, the quantity of publications increased. Elder Frederick W. Evans published scores of small pamphlets during this period. Many Shaker authors, like Evans, wrote less about the substance of the Shaker faith per se, and more about political and worldly matters of interest to them in the decades prior to 1900. Many topics of concern to the late nineteenth-century Shaker were radical statements of that day, yet curiously anticipatory of present-day political issues.

Of great interest to collectors are the many pamphlets, catalogs, and broadsides relating to the fruits of Shaker agriculture, their medicinal and seed industries, and other manufactures, most notably the chair industry. Many of these items were Shaker-printed, and some are quite aesthetically pleasing. Just about every society used the printed word to advertise its products and wares. One can find catalogs and advertising material relating to Shaker candies, washing machines, hernia trusses, hair restorer, medicines, flowers, mowing machines, cattle, rocking chairs, fancy boxes...just to name a few. The variety of Shaker paper relating to their commercial endeavors is as voluminous as was their varied manufactures.

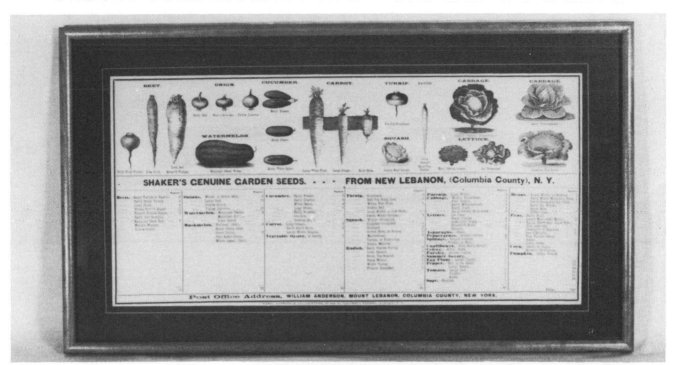

Seed box interior panel label, last
quarter of the nineteenth century.
(Miller Collection)

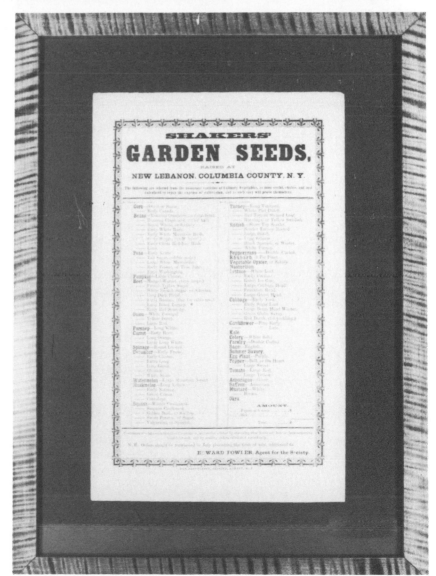

Broadside advertising Shaker garden
seeds, New Lebanon, c. 1840. (Miller
Collection)

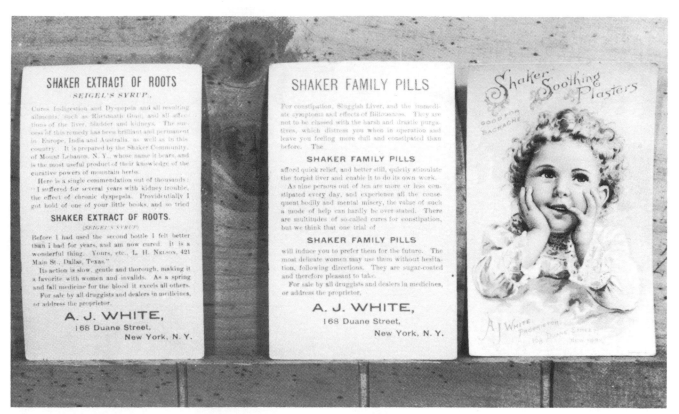

A.J. White trade cards.

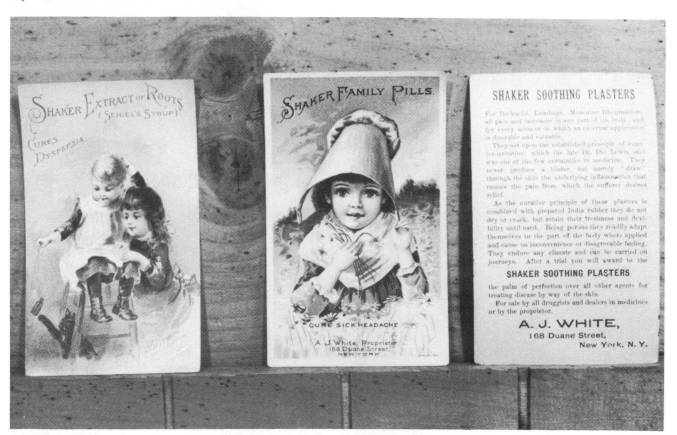

A.J. White trade cards.

Wrapping paper. Herbs and other medicinal preparations were often wrapped in papers with the label printed on the face. This example is Shaker-printed and dates from the middle part of the nineteenth century. (Miller Collection)

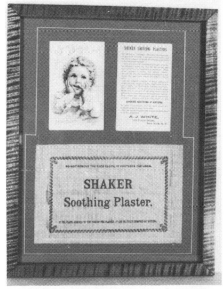

A.J. White Products. Many Shaker products were aggressively marketed by the New York firm of A.J. White and Company. The "plaster" was manufactured by the Shakers and the trade card was designed to advertise the product. Both date from the mid-nineteenth century. (Miller Collection)

Many collectors are enchanted with the colorful and interesting almanacs, pamphlets, and ephemera published by the New York firm of A. J. White and Company. White had a close business relationship with the Mount Lebanon Shakers, one which was mutually profitable. He marketed a vast quantity of Shaker-made products, particularly medicinal preparations, and gave much attention to advertising. One can find A. J. White *Shaker Almanacs* dated from the 1880s and 1890s, not to mention a variety of other interesting pamphlets, advertising gimmicks, and trade cards.

The Shaker Societies published a monthly between 1871 and 1899, and considered this periodical to be their most important missionary instrument. The format and title changed several times during this period. First issued as *The Shaker* in 1871 and 1872 (and later in 1876 and 1877), it also ran as *The Shaker and Shakeress* between 1873 and 1875, *The Shaker Manifesto* from 1878 to 1882, and finally *The Manifesto* from 1883 onward. Collectors can find both individual monthly issues as well as bound volumes containing one or more years of run. Many issues include illustrations, and all are quite entertaining. They contain histories of the Shaker communities, views on current topics, recipes, and information on each of the societies and so forth.

Most publications by the Shakers were authored by eastern Shaker authors and communities. Publications from the Ohio and Kentucky societies are generally earlier on the average, and scarcer. Of the eastern communities, works published by New Lebanon (later Mount Lebanon) and Canterbury authors account for, perhaps, the majority of works.

There are many other types of Shaker imprints, all of interest to student and collector alike. Common from the 1870s to the early 1900s were biographical and autobiographical accounts of Shaker sisters and brothers. The early and mid-nineteenth century found Shaker writers busy addressing legal issues, stating defenses of their faith and social order, and petitioning their state legislatures for reform and relief from oppressive laws. Of interest to many collectors are the books and pamphlets written by those who were opposed to Shakerism. There are scores of such works, some more hostile than others, written by former members in some instances, or by those who had an ax to grind for one reason or another. The titles of some of these works give ample evidence of the point of view contained within: *The Rise and Progress of the Serpent from the Garden. . .; Shakerism Unmasked;* or *A Shock to Shakerism, or a Serious Refutation of the Divine Idolatry of Ann Lee.*

There exists a vast quantity of publications by writers who visited the Shakers and provided detailed descriptions of their worship services, their villages and accounts of their farms, industries, and activities. These books and pamphlets offer interesting views about them from those who were not members of the societies.

Ephemera. There is a rich and pleasing variety of Shaker ephemera that has survived to the present day. Ephemera, as it relates to "paper," is loosely defined as a printed, written, photographic or other similar item, usually on paper, that had a specific purpose, usually for a stated point or period of time. Generally, the realm of Shaker ephemera includes letters, some broadside and advertising materials, labels and paper packettes and envelopes, photographs and other illustrations, stationery and billheads, shipping tags, candy boxes and much more.

The ephemera collector does not have the challenge of proving authenticity as does the collector of furniture or small crafts. A close inspection of the item, whether a postal card depicting Shaker Sisters, or a colorful can label illustrating Shaker String Beans, can usually allow the collector enough evidence to pronounce the item as genuine. Don't be fooled, however, into thinking that just because the Shaker item is "paper," automatically means it is "the real thing." Counterfeit Shaker Seed and Medicinal Broadsides are known to exist; they look like the real thing because they are duplicated on old paper and framed in old frames, in some instances. A few ephemeral works have been reprinted without any statement of their more recent origins, and sometimes are sold as the original. Herb and Seed Labels have been reprinted, sometimes using printing methods common during the last century; hence, the final product is disarmingly similar to genuine labels. Any paper ephemeral item should be closely examined before purchase.

Quite popular, very colorful, and available if one looks hard enough, are the bright and pleasing can labels used on canned goods produced by the Shakers. Most, if not all, are from the Watervliet and Mount Lebanon communities, and tend to date from the 1870s to as late as the 1920s. They are generally illustrated with the product contained within (e.g., Lima Beans, Tomatoes, String Beans, Butter Beans, etc.).

There exists a vast variety of labels for an untold number of Shaker-made and packaged seeds, medicinal compounds, herbs, and other produce. They range in size from the miniscule (less than an inch square) to a size that can allow framing, whether singly or in groups. Similar are the papers used to wrap herbs and envelopes of various sizes used for seeds. Many, but not all, of these printed works clearly define the product as Shaker-manufactured. Many also indicate the community where the product was grown or prepared. Such ephemeral examples date from as early as the 1810s, though most are from the middle and latter parts of the nineteenth century. Mount (or New) Lebanon, Canterbury, and to a lesser degree, Watervliet (New

Seed packets, envelope-like packets, Enfield, New Hampshire, middle part of the nineteenth century. (Miller Collection)

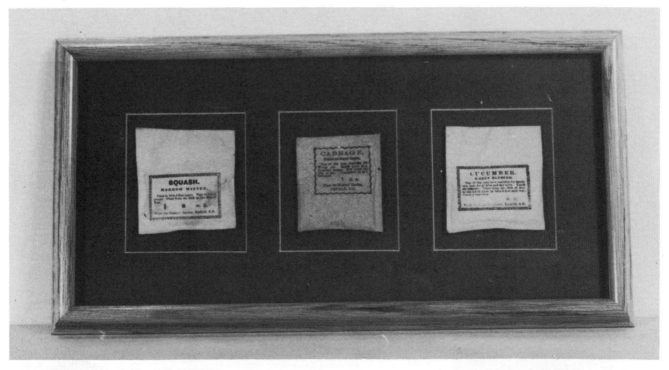

York) and Sabbathday Lake examples are more easily obtained. Like items from Shirley, Harvard, both Enfields, and Alfred are substantially scarcer and more difficult to locate. Examples from other communities, particularly the Ohio and Kentucky villages, are quite rare.

There are a few early nineteenth-century engravings or like illustrations, depicting the Shakers. More readily available are similar illustrations, including lithographs from nineteenth-century periodicals. These illustrate several of the villages, sisters and/or brethren in Shaker garb, or other aspects of the societies. Some have been given a "recent" overhaul, with the addition of hand-tinting or coloring, or matting/framing.

Early photographic prints of the Shakers and their villages, while scarce, can be obtained, oftentimes at reasonable prices. It was not until about 1880 that the Shakers themselves began to avail themselves of local photographers for portraits. The relatively larger cabinet photographs and smaller cartes de visites, often depict Shakers in period costume and are quite beautiful. One needs to exercise caution, however, when buying period photographs of Shakers. Sometimes, like photographs of Quaker women or members of similarly-clad German pietistic sects are sold as "Shaker."

There are other forms of photographica illustrating "all things Shakers," but perhaps none quite so popular as the great variety of stereographic views. Some date as early as the 1860s, and are a valuable pictoral record of the nineteenth-century Shaker communities and residents.

More readily available and far less expensive are postal cards illustrating Shakers, their villages, and all aspects of Shaker life at the turn of the century (and after). They became popular shortly after 1900, and several of the societies published their own series of postals, including Alfred, Enfield (Connecticut), Sabbathday Lake, and Canterbury. There exists a great variety of postal card views of Mount Lebanon, many of which are scarce, and others of great curiosity and interest.

Paper labels from cans of tomatoes and butter beans. These labels were designed for use on cans of Shaker food products distributed to grocers in the Mount Lebanon, New York, area and western New England. Periodically stacks of labels that were received from the printers and never utilized turn up.

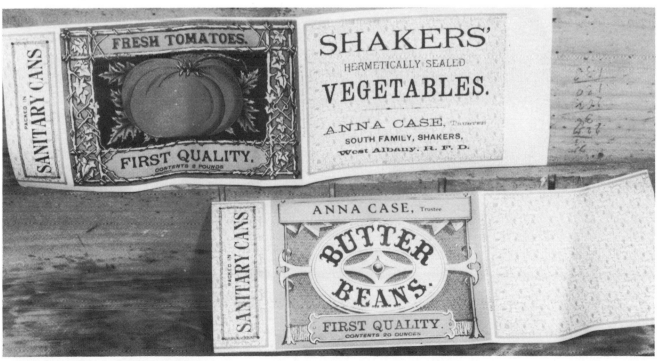

107

Early seed packet from Canterbury, New Hampshire, second quarter of the nineteenth century. The initials "FW" denote trustee Francis Winkley of Canterbury. The use of a Shaker trustee's name or initial was a common practice among the societies. (Miller Collection)

Again, the western societies are not represented significantly, for by 1900, when the postal card became common, these villages were in serious decline, and some were closing.

Embroidered items are popular, though a not-too-great variety exists. The most popular items appear as an advertising item for the Shaker cloaks manufactured at Mount Lebanon (not the intent of the Shakers who had them made in England). One can still find embroidered cloak labels from several societies, intended to be sewn into the interior lining. There are similar labels for Shaker-made sweaters which can still be had.

The list of ephemera goes on and on. There are billheads from Shaker communities and from those who marketed Shaker goods. Shipping tags, trade cards, advertising gimmicks, envelopes, letters, calling cards...all of interest if they have something to say or to do with the Shakers.

Perhaps the most useful resource for the collector desiring to "get serious" about collecting Shaker paper, whether imprints or ephemera, is Mary Richmond's two-volume *Shaker Literature, A Bibliography,* which contains more than 4,000 entries on Shaker works, whether by or about them. It contains a wealth of information on many of the commercially related Shaker publications. While no bibliography can be perfect or complete (and Richmond's is no exception), it is, unquestionably, the most important reference for the collector of paper.

Finding the paper you seek is always a challenge, and it can be a lot of fun. There is no single source that proves to be the gold mine you hope for. Rather, the material is generally difficult to find and requires some serious "digging around" at antiquarian book and ephemera shows, book and other antique auctions, and even antique and book shops. There are several booksellers who issue catalogs and lists and who have Shaker paper available from time to time.

All in all, collecting Shaker paper is still within the reach of most, both in terms of the cost of the collectible and the general availability of the material. Beyond that, it can be viewed and read, and certainly will provide any collector with a deeper understanding and appreciation of the people called Shakers.

10

Lists

Nine Shaker Contacts with Leaders from the "World"

1784 Marquis de Lafayette visits Niskeyuna, New York
1817 President James Monroe visits Enfield, New Hampshire
1819 Monroe and Andrew Jackson visit South Union, Kentucky
1825 Henry Clay visits Union Village, Ohio
1829 Clay visits South Union, Kentucky
1848 Franklin Pierce (later the fourteenth president of the United States) represents the Shakers in a New Hampshire lawsuit
1862 Two Shakers meet with President Lincoln in Washington, D.C., concerning army deferments for male members
1864 Shakers receive letter from Lincoln thanking them for a gift of a rocking chair
1906 Two Shaker sisters from Mount Lebanon meet with President Teddy Roosevelt about world peace

Ten Places to View Shaker Collections

Shakertown at Pleasant Hill, Harrodsburg, Kentucky
Shaker Museum, Sabbathday Lake, Maine
Hancock Shaker Community, Pittsfield, Massachusetts
Greenfield Village, Dearborn, Michigan
Canterbury Shaker Village, Canterbury, New Hampshire
Shaker Museum, Old Chatham, New York
Golden Lamb Inn, Lebanon, Ohio
Warren County Historical Society Museum, Lebanon, Ohio
Shelburne Museum, Shelburne, Vermont
Smithsonian Institute, Washington D.C.

Nineteen Shaker Communities and Their Dates of Operation

Mount (New) Lebanon, New York	1787–1947
Watervliet, New York	1787–1938
Enfield, Connecticut	1790–1917
Hancock, Massachusetts	1790–1960
Harvard, Massachusetts	1791–1919
Canterbury, New Hampshire	1792–present
Tyringham, Massachusetts	1792–1873
Shirley, Massachusetts	1793–1908
Enfield, New Hampshire	1793–1923
Alfred, Maine	1793–1931
Sabbathday Lake, Maine	1794–present
Union Village, Ohio	1805–1910
Watervliet, Ohio	1806–1910
Pleasant Hill, Kentucky	1806–1910
South Union, Kentucky	1807–1922
West Union, Indiana	1810–1827
North Union, Ohio	1822–1889
Whitewater, Ohio	1824–1907
Groveland, New York	1836–1892

Six Shaker Communities That Briefly Flourished in the Nineteenth Century

Gorham, Maine	1804–1819
Savoy, Massachusetts	1817–1825
Sodus Bay, New York	1826–1836
White Oak, Georgia	1898–1902
Narcoossee, Florida	1896–1910
Philadelphia, Pennsylvania	1860s

The Philadelphia Shakers were a group of black women initially led by Mother Rebecca Jackson. The group moved from Philadelphia to Watervliet, New York, and back to Philadelphia in the early 1860s.

Eighteen Shaker Inventions and Improvements

Fire engine and hose cart
Improved beehives
Improved truss for hernias
Improved sun-dial
Cast iron fence post
New method for drying sweet corn
Clothespins
Cut nails
Folding stereoscope
Mechanical apple corer that quartered and cored
Flat broom
Improved washing machine
Improved windmill
Circular saw
Machine to cut "splint" for baskets
Fertilizing machine
Revolving harrow
Revolving oven

Five Department Stores That Sold Shaker Chairs in the 1880s

Oliver McClintock and Company, Pittsburgh, Pennsylvania
Gayton Furniture Company, Cleveland, Ohio
Troxel Brothers, Burlington, Iowa
Marshall Field and Company, Chicago, Illinois
Henry Turner and Company, Boston, Massachusetts

Ten of the Shaker's Millennial Laws

In October, 1845, a revised listing of the Millennial Laws was issued from New Lebanon, New York. The Laws were designed to regulate the daily life of a Shaker brother or sister. The rules came through divine revelation from Mother Ann Lee.

By the 1870s life began to change in many communities and the Millennial Laws became less of a factor. Private bedrooms, wallpaper, flowered curtains, and crocheted doilies became acceptable in the surviving communities.

Henry Blinn remarked, "As the earth or world moves, the people must move with it or be left in the rear."

a. Beasts may not be called by the given or Christian names of persons.
b. No fowls may be set on the eggs of fowls of different kinds.
c. Beadings, mouldings, and cornices, which are merely for fancy, may not be made by Believers.
d. Oval or nice boxes may be stained reddish or yellow, but not varnished.
e. Believers should not compare their brethren and sisters to filthy vagabonds of the world.
f. No one should carelessly pass over small things, as a pin, a kernel of grain, thinking it too small to pick up, for if we do, our Heavenly Father will consider it too small too for him to bestow his blessing upon.
g. No private possessions should be kept under lock and key security, without liberty from the Elders.
h. When a pane of glass gets broken in a front window, it must be mended before the Sabbath.
i. Brethren and sisters must not spit out the windows, on the floors, walks, cellar bottoms, nor in sinks.
j. No person or persons may have privacies in communications, written, spoken, or in action, intentionally secreted from the Elders.

Eleven Acts Shaker Brothers and Sisters Could Not Commit

In 1828 William Haskett published one in a growing series of exposés of the Shaker life-style. His book, *Shakerism Unmasked,* outlined a number of "contrary to order" acts that he was prevented from doing when he was a member of the faith.

According to Haskett it was "contrary to order" for Shaker brothers and sisters to commit the following:
Give the cooks any directions
Be alone together in a room without company
Jointly milk a cow
To shake hands with a "world's" woman without confessing it
Employ a "world's" doctor
To pick fruit on the Sabbath
To eat any fruit after supper

To eat bread until it is out of the oven twenty-four hours
To kneel with the left knee first
Play with dogs and cats
To throw water out of the window

Three Millennial Laws That Governed Furniture Construction

No one shall take tools, belonging or charged of others, without obtaining liberty for the same, if the person can consistently be found who takes charge of them.

No one may smoke in their shops an hour prior to leaving them for the night and no one may smoke and work at the same time.

No individuals shall make, or get made, bring in or cause to be brought in, any new-fashioned tool, article, or accommodation, without the full approbation of the leader of the family.

Essentials for Success Developed by the Shakers for Their Numerous Industries

Regular hours
Prearranged schedules
Fixed responsibilities

The First Four Shaker Spiritual Leaders in America

Mother Ann Lee (died 1784)
Elder James Whitaker (died 1787)
Elder Joseph Meacham (died 1796)
Mother Lucy Wright (died 1821)

Six Factors Many Authorities Feel Brought About the Decline of the Shaker Movement in America

The first and second generations of Shaker leaders were replaced by less skillful leaders who could not maintain the industries and recruit new members.

The rise of factories in the industrial North after the Civil War made mass-produced household goods more available and forced the Shakers to close down many "industries" that relied upon handwork.

The nation's changing philosophy toward material goods and increased amounts of leisure time brought about internal changes with the Shaker way of life also.

The Shakers could no longer hold their younger believers and found it increasingly more difficult to recruit new members.

As the nineteenth century wore on and the growing disparity in the ratio of men to women increased, the number of skilled craftsmen diminished significantly.

The increased wealth of the Shakers brought on by rising land values was coupled with a falling membership that forced the Shakers to hire outside workers or to sell their holdings.